THE DEHUMANIZATION OF ART

THE
DEHUMANIZATION
OF ART

AND OTHER ESSAYS ON ART, CULTURE, AND LITERATURE

BY JOSÉ ORTEGA Y GASSET

PRINCETON UNIVERSITY PRESS
PRINCETON, NEW JERSEY

CONTENTS

THE
DEHUMANIZATION
OF ART

"Non creda donna Berta e ser Martino . . ."

—DIVINA COMMEDIA, PARADISO, XIII

*A*mong the many excellent, though inadequately developed, ideas of the eminent French philosopher J. M. Guyau we must count his intention to study art from a sociological point of view.* The subject may at first appear unprofitable. Approaching art from the side of its social effects looks very much like putting the cart before the horse, or studying a man by his shadow. The social effects of art seem such an accidental thing, so remote from the aesthetic essence that it does not quite appear how, starting from them, we can ever hope to penetrate into the inner frame of styles. Guyau doubtless failed to make the best of his ingenious idea. His short life and tragic rushing toward death prevented him from clarifying his insight and distinguishing the obvious aspects from the hidden but more relevant ones. We may almost say that of his book *Art from a Sociological Point of View* only the title exists; the rest is yet to be written.

The fruitfulness of a sociology of art was revealed to me unexpectedly when, a few years ago, I wrote a brief study on the new epoch in music which begins with Debussy.† My purpose was to define as clearly as possible the difference of style between the new music and traditional music. The problem was strictly aesthetic, and yet it turned out that the shortest way of tackling it

* Jean Marie Guyau, *L'art au point de vue sociologique.* Paris: F. Alcan, 1897.
† Cf. the author's essay "Musicalia" in *El Espectador* (Madrid: Calpe, 1921), vol. III, 25.

started from a sociological fact: the unpopularity of the new music.

In the following I will speak more in general and consider all the arts that are still somewhat alive in the Western world—that is, not only music, but also painting, poetry, and the theater. It is amazing how compact a unity every historical epoch presents throughout its various manifestations. One and the same inspiration, one and the same biological style, are recognizable in the several branches of art. The young musician—himself unaware of it—strives to realize in his medium the same aesthetic values as his contemporary colleagues— the poet, the painter, the playwright—in theirs. And this identity of artistic purpose necessarily produces identical sociological consequences. In fact, the unpopularity of the new music has its counterpart in a similar unpopularity of the other Muses. All modern art is unpopular, and it is so not accidentally and by chance, but essentially and by fate.

It might be said that every newcomer among styles passes through a stage of quarantine. The battle of *Hernani* comes to mind, and all the other skirmishes connected with the advent of Romanticism. However, the unpopularity of present-day art is of a different kind. A distinction must be made between what is not popular and what is unpopular. A new style takes some time in winning popularity; it is not popular, but it is not unpopular either. The break-through of Romanticism, although a frequently cited example, is, as a sociological phenomenon, exactly the opposite of the pres-

ent situation of art. Romanticism was very quick in winning "the people" to whom the old classical art had never appealed. The enemy with whom Romanticism had to fight it out was precisely a select minority irretrievably sold to the classical forms of the "*ancien régime*" in poetry. The works of the romanticists were the first, after the invention of printing, to enjoy large editions. Romanticism was the prototype of a popular style. First-born of democracy, it was coddled by the masses.

Modern art, on the other hand, will always have the masses against it. It is essentially unpopular; moreover, it is antipopular. Any of its works automatically produces a curious effect on the general public. It divides the public into two groups: one very small, formed by those who are favorably inclined towards it; another very large—the hostile majority. (Let us ignore that ambiguous fauna—the snobs.) Thus the work of art acts like a social agent which segregates from the shapeless mass of the many two different castes of men.

Which is the differentiating principle that creates these two antagonistic groups? Every work of art arouses differences of opinion. Some like it, some don't; some like it more, some like it less. Such disagreements have no organic character, they are not a matter of principles. A person's chance disposition determines on which side he will fall. But in the case of the new art the split occurs in a deeper layer than that on which differences of personal taste reside. It is not that the majority does not *like* the art of the young and the minor-

ity likes it, but that the majority, the masses, do not *understand* it. The old bigwigs who were present at the performance of *Hernani* understood Victor Hugo's play very well; precisely because they understood it they disliked it. Faithfully adhering to definite aesthetic norms, they were disgusted at the new artistic values which this piece of art proposed to them.

"From a sociological point of view" the characteristic feature of the new art is, in my judgment, that it divides the public into the two classes of those who understand it and those who do not. This implies that one group possesses an organ of comprehension denied to the other—that they are two different varieties of the human species. The new art obviously addresses itself not to everybody, as did Romanticism, but to a specially gifted minority. Hence the indignation it arouses in the masses. When a man dislikes a work of art, but understands it, he feels superior to it; and there is no reason for indignation. But when his dislike is due to his failure to understand, he feels vaguely humiliated and this rankling sense of inferiority must be counterbalanced by indignant self-assertion. Through its mere presence, the art of the young compels the average citizen to realize that he is just this—the average citizen, a creature incapable of receiving the sacrament of art, blind and deaf to pure beauty. But such a thing cannot be done after a hundred years of adulation of the masses and apotheosis of the people. Accustomed to ruling supreme, the masses feel that the new art, which is the art of a privileged aristocracy of finer senses, endangers their

rights as men. Whenever the new Muses present themselves, the masses bristle.

For a century and a half the masses have claimed to be the whole of society. Stravinski's music or Pirandello's drama have the sociological effect of compelling the people to recognize itself for what it is: a component among others of the social structure, inert matter of the historical process, a secondary factor in the cosmos of spiritual life. On the other hand, the new art also helps the elite to recognize themselves and one another in the drab mass of society and to learn their mission which consists in being few and holding their own against the many.

A time must come in which society, from politics to art, reorganizes itself into two orders or ranks: the illustrious and the vulgar. That chaotic, shapeless, and undifferentiated state without discipline and social structure in which Europe has lived these hundred and fifty years cannot go on. Behind all contemporary life lurks the provoking and profound injustice of the assumption that men are actually equal. Each move among men so obviously reveals the opposite that each move results in a painful clash.

If this subject were broached in politics the passions aroused would run too high to make oneself understood. Fortunately the aforementioned unity of spirit within a historical epoch allows us to point out serenely and with perfect clarity in the germinating art of our time the same symptoms and signals of a moral revision

that in politics present themselves obscured by low passions.

"*Nolite fieri,*" the evangelist exhorts us, "*sicut equus et mulus quibus non est intellectus*"—do not act like horses and mules that lack understanding. The masses kick and do not understand. Let us try to do better and to extract from modern art its essential principle. That will enable us to see in what profound sense modern art is unpopular.

ARTISTIC ART

❬ If the new art is not accessible to every man this implies that its impulses are not of a generically human kind. It is an art not for men in general but for a special class of men who may not be better but who evidently are different.

One point must be clarified before we go on. What is it the majority of people call aesthetic pleasure? What happens in their minds when they "like" a work of art; for instance, a theatrical performance? The answer is easy. A man likes a play when he has become interested in the human destinies presented to him, when the love and hatred, the joys and sorrows of the personages so move his heart that he participates in it all as though it were happening in real life. And he calls a work "good" if it succeeds in creating the illusion necessary to make the imaginary personages appear like living persons. In poetry he seeks the passion and pain of the man be-

hind the poet. Paintings attract him if he finds on them figures of men or women whom it would be interesting to meet. A landscape is pronounced "pretty" if the country it represents deserves for its loveliness or its grandeur to be visited on a trip.

It thus appears that to the majority of people aesthetic pleasure means a state of mind which is essentially undistinguishable from their ordinary behavior. It differs merely in accidental qualities, being perhaps less utilitarian, more intense, and free from painful consequences. But the object towards which their attention and, consequently, all their other mental activities are directed is the same as in daily life: people and passions. By art they understand a means through which they are brought in contact with interesting human affairs. Artistic forms proper—figments, fantasy— are tolerated only if they do not interfere with the perception of human forms and fates. As soon as purely aesthetic elements predominate and the story of John and Mary grows elusive, most people feel out of their depth and are at a loss what to make of the scene, the book, or the painting. As they have never practiced any other attitude but the practical one in which a man's feelings are aroused and he is emotionally involved, a work that does not invite sentimental intervention leaves them without a cue.

Now, this is a point which has to be made perfectly clear. Not only is grieving and rejoicing at such human destinies as a work of art presents or narrates a very different thing from true artistic pleasure, but preoccu-

pation with the human content of the work is in principle incompatible with aesthetic enjoyment proper.

We have here a very simple optical problem. To see a thing we must adjust our visual apparatus in a certain way. If the adjustment is inadequate the thing is seen indistinctly or not at all. Take a garden seen through a window. Looking at the garden we adjust our eyes in such a way that the ray of vision travels through the pane without delay and rests on the shrubs and flowers. Since we are focusing on the garden and our ray of vision is directed toward it, we do not see the window but look clear through it. The purer the glass, the less we see it. But we can also deliberately disregard the garden and, withdrawing the ray of vision, detain it at the window. We then lose sight of the garden; what we still behold of it is a confused mass of color which appears pasted to the pane. Hence to see the garden and to see the windowpane are two incompatible operations which exclude one another because they require different adjustments.

Similarly a work of art vanishes from sight for a beholder who seeks in it nothing but the moving fate of John and Mary or Tristan and Isolde and adjusts his vision to this. Tristan's sorrows are sorrows and can evoke compassion only in so far as they are taken as real. But an object of art is artistic only in so far as it is not real. In order to enjoy Titian's portrait of Charles the Fifth on horseback we must forget that this is Charles the Fifth in person and see instead a portrait—that is, an image, a fiction. The portrayed person and

his portrait are two entirely different things; we are interested in either one or the other. In the first case we "live" with Charles the Fifth, in the second we look at an object of art.

But not many people are capable of adjusting their perceptive apparatus to the pane and the transparency that is the work of art. Instead they look right through it and revel in the human reality with which the work deals. When they are invited to let go of this prey and to direct their attention to the work of art itself they will say that they cannot see such a thing, which indeed they cannot, because it is all artistic transparency and without substance.

During the nineteenth century artists proceeded in all too impure a fashion. They reduced the strictly aesthetic elements to a minimum and let the work consist almost entirely in a fiction of human realities. In this sense all normal art of the last century must be called realistic. Beethoven and Wagner were realistic, and so was Chateaubriand as well as Zola. Seen from the vantage-point of our day Romanticism and Naturalism draw closer together and reveal their common realistic root.

Works of this kind are only partially works of art, or artistic objects. Their enjoyment does not depend upon our power to focus on transparencies and images, a power characteristic of the artistic sensibility; all they require is human sensibility and willingness to sympathize with our neighbor's joys and worries. No wonder that nineteenth century art has been so popular; it is

made for the masses inasmuch as it is not art but an extract from life. Let us remember that in epochs with two different types of art, one for minorities and one for the majority, the latter has always been realistic.*

I will not now discuss whether pure art is possible. Perhaps it is not; but as the reasons that make me inclined to think so are somewhat long and difficult the subject better be dropped. Besides, it is not of major importance for the matter in hand. Even though pure art may be impossible there doubtless can prevail a tendency toward a purification of art. Such a tendency would effect a progressive elimination of the human, all too human, elements predominant in romantic and naturalistic production. And in this process a point can be reached in which the human content has grown so thin that it is negligible. We then have an art which can be comprehended only by people possessed of the peculiar gift of artistic sensibility—an art for artists and not for the masses, for "quality" and not for hoi polloi.

That is why modern art divides the public into two classes, those who understand it and those who do not understand it—that is to say, those who are artists and those who are not. The new art is an artistic art.

I do not propose to extol the new way in art or to condemn the old. My purpose is to characterize them as the zoologist characterizes two contrasting species. The new art is a world-wide fact. For about twenty years now

* For instance in the Middle Ages. In accordance with the division of society in the two strata of noblemen and commoners, there existed an aristocratic art which was "conventional" and "idealistic," and a popular art which was realistic and satirical.

the most alert young people of two successive genera-
tions—in Berlin, Paris, London, New York, Rome,
Madrid—have found themselves faced with the unde-
niable fact that they have no use for traditional art;
moreover, that they detest it. With these young people
one can do one of two things: shoot them, or try to un-
derstand them. As soon as one decides in favor of the
latter it appears that they are endowed with a perfectly
clear, coherent, and rational sense of art. Far from be-
ing a whim, their way of feeling represents the inevi-
table and fruitful result of all previous artistic achieve-
ment. Whimsical, arbitrary, and consequently unprofit-
able it would be to set oneself against the new style and
obstinately remain shut up in old forms that are ex-
hausted and the worse for wear. In art, as in morals,
what ought to be done does not depend on our personal
judgment; we have to accept the imperative imposed by
the time. Obedience to the order of the day is the most
hopeful choice open to the individual. Even so he may
achieve nothing; but he is much more likely to fail if he
insists on composing another Wagnerian opera, another
naturalistic novel.

In art repetition is nothing. Each historical style can
engender a certain number of different forms within a
generic type. But there always comes a day when the
magnificent mine is worked out. Such, for instance, has
been the fate of the romantico-naturalistic novel and
theater. It is a naïve error to believe that the present in-
fecundity of these two genres is due to lack of talent.
What happens is that the possible combinations within

these literary forms are exhausted. It must be deemed fortunate that this situation coincides with the emergence of a new artistic sensibility capable of detecting other untouched veins.

When we analyze the new style we find that it contains certain closely connected tendencies. It tends (1) to dehumanize art, (2) to avoid living forms, (3) to see to it that the work of art is nothing but a work of art, (4) to consider art as play and nothing else, (5) to be essentially ironical, (6) to beware of sham and hence to aspire to scrupulous realization, (7) to regard art as a thing of no transcending consequence.

In the following I shall say a few words about each of these features of modern art.

A FEW DROPS OF PHENOMENOLOGY

❡ A great man is dying. His wife is by his bedside. A doctor takes the dying man's pulse. In the background two more persons are discovered: a reporter who is present for professional reasons, and a painter whom mere chance has brought here. Wife, doctor, reporter, and painter witness one and the same event. Nonetheless, this identical event—a man's death—impresses each of them in a different way. So different indeed that the several aspects have hardly anything in common. What this scene means to the wife who is all grief has so little to do with what it means to the painter who looks on impassively that it seems doubtful whether the two can be said to be present at the same event.

It thus becomes clear that one and the same reality may split up into many diverse realities when it is beheld from different points of view. And we cannot help asking ourselves: Which of all these realities must then be regarded as the real and authentic one? The answer, no matter how we decide, cannot but be arbitrary. Any preference can be founded on caprice only. All these realities are equivalent, each being authentic for its corresponding point of view. All we can do is to classify the points of view and to determine which among them seems, in a practical way, most normal or most spontaneous. Thus we arrive at a conception of reality that is by no means absolute, but at least practical and normative.

As for the points of view of the four persons present at the deathbed, the clearest means of distinguishing them is by measuring one of their dimensions, namely the emotional distance between each person and the event they all witness. For the wife of the dying man the distance shrinks to almost nothing. What is happening so tortures her soul and absorbs her mind that it becomes one with her person. Or to put it inversely, the wife is drawn into the scene, she is part of it. A thing can be seen, an event can be observed, only when we have separated it from ourselves and it has ceased to form a living part of our being. Thus the wife is not present at the scene, she is in it. She does not behold it, she "lives" it.

The doctor is several degrees removed. To him this is a professional case. He is not drawn into the event with

the frantic and blinding anxiety of the poor woman. However it is his bounden duty as a doctor to take a serious interest, he carries responsibility, perhaps his professional honor is at stake. Hence he too, albeit in a less integral and less intimate way, takes part in the event. He is involved in it not with his heart but with the professional portion of his self. He too "lives" the scene although with an agitation originating not in the emotional center, but in the professional surface, of his existence.

When we now put ourselves in the place of the reporter we realize that we have traveled a long distance away from the tragic event. So far indeed that we have lost all emotional contact with it. The reporter, like the doctor, has been brought here for professional reasons and not out of a spontaneous human interest. But while the doctor's profession requires him to interfere, the reporter's requires him precisely to stay aloof; he has to confine himself to observing. To him the event is a mere scene, a pure spectacle on which he is expected to report in his newspaper column. He takes no feeling part in what is happening here, he is emotionally free, an outsider. He does not "live" the scene, he observes it. Yet he observes it with a view to telling his readers about it. He wants to interest them, to move them, and if possible to make them weep as though they each had been the dying man's best friend. From his schooldays he remembers Horace's recipe: *"Si vis me flere dolendum est primum ipsi tibi"*—if you want me to weep you must first grieve yourself.

Obedient to Horace the reporter is anxious to pretend emotion, hoping that it will benefit his literary performance. If he does not "live" the scene he at least pretends to "live" it.

The painter, in fine, completely unconcerned, does nothing but keep his eyes open. What is happening here is none of his business; he is, as it were, a hundred miles removed from it. His is a purely perceptive attitude; indeed, he fails to perceive the event in its entirety. The tragic inner meaning escapes his attention which is directed exclusively toward the visual part— color values, lights, and shadows. In the painter we find a maximum of distance and a minimum of feeling intervention.

The inevitable dullness of this analysis will, I hope, be excused if it now enables us to speak in a clear and precise way of a scale of emotional distances between ourselves and reality. In this scale, the degree of closeness is equivalent to the degree of feeling participation; the degree of remoteness, on the other hand, marks the degree to which we have freed ourselves from the real event, thus objectifying it and turning it into a theme of pure observation. At one end of the scale the world— persons, things, situations—is given to us in the aspect of "lived" reality; at the other end we see everything in the aspect of "observed" reality.

At this point we must make a remark that is essential in aesthetics and without which neither old art nor new art can be satisfactorily analyzed. Among the diverse aspects of reality we find one from which all the others

derive and which they all presuppose: "lived" reality. If nobody had ever "lived" in pure and frantic abandonment a man's death, the doctor would not bother, the readers would not understand the reporter's pathos, and the canvas on which the painter limned a person on a bed surrounded by mourning figures would be meaningless. The same holds for any object, be it a person, a thing, or a situation. The primal aspect of an apple is that in which I see it when I am about to eat it. All its other possible forms—when it appears, for instance, in a Baroque ornament, or on a still life of Cézanne's, or in the eternal metaphor of a girl's apple cheeks—preserve more or less that original aspect. A painting or a poem without any vestiges of "lived" forms would be unintelligible, i.e., nothing—as a discourse is nothing whose every word is emptied of its customary meaning.

That is to say, in the scale of realities "lived" reality holds a peculiar primacy which compels us to regard it as "the" reality. Instead of "lived" reality we may say "human" reality. The painter who impassively witnesses the death scene appears "inhuman." In other words, the human point of view is that in which we "live" situations, persons, things. And, vice versa, realities—a woman, a countryside, an event—are human when they present the aspect in which they are usually "lived."

As an example, the importance of which will appear later, let us mention that among the realities which constitute the world are our ideas. We use our ideas in a "human" way when we employ them for thinking

things. Thinking of Napoleon, for example, we are normally concerned with the great man of that name. A psychologist, on the other hand, adopts an unusual, "inhuman" attitude when he forgets about Napoleon and, prying into his own mind, tries to analyze his idea of Napoleon as such idea. His perspective is the opposite of that prevailing in spontaneous life. The idea, instead of functioning as the means to think an object with, is itself made the object and the aim of thinking. We shall soon see the unexpected use which the new art has made of this "inhuman" inversion.

FIRST INSTALLMENT ON THE DEHUMANIZATION OF ART

⟨ With amazing swiftness modern art has split up into a multitude of divergent directions. Nothing is easier than to stress the differences. But such an emphasis on the distinguishing and specific features would be pointless without a previous account of the common fund that in a varying and sometimes contradictory manner asserts itself throughout modern art. Did not Aristotle already observe that things differ in what they have in common? Because all bodies are colored we notice that they are differently colored. Species are nothing if not modifications of a genus, and we cannot understand them unless we realize that they draw, in their several ways, upon a common patrimony.

I am little interested in special directions of modern

art and, but for a few exceptions, even less in special works. Nor do I, for that matter, expect anybody to be particularly interested in my valuation of the new artistic produce. Writers who have nothing to convey but their praise or dispraise of works of art had better abstain from writing. They are unfit for this arduous task.

The important thing is that there unquestionably exists in the world a new artistic sensibility.* Over against the multiplicity of special directions and individual works, the new sensibility represents the generic fact and the source, as it were, from which the former spring. This sensibility it is worth while to define. And when we seek to ascertain the most general and most characteristic feature of modern artistic production we come upon the tendency to dehumanize art. After what we have said above, this formula now acquires a tolerably precise meaning.

Let us compare a painting in the new style with one of, say, 1860. The simplest procedure will be to begin by setting against one another the objects they represent: a man perhaps, a house, or a mountain. It then appears that the artist of 1860 wanted nothing so much as to give to the objects in his picture the same looks and airs they possess outside it when they occur as parts of the "lived" or "human" reality. Apart from this he may have been animated by other more intricate aesthetic

* This new sensibility is a gift not only of the artist proper but also of his audience. When I said above that the new art is an art for artists I understood by "artists" not only those who produce this art but also those who are capable of perceiving purely artistic values.

ambitions, but what interests us is that his first concern was with securing this likeness. Man, house, mountain are at once recognized, they are our good old friends; whereas on a modern painting we are at a loss to recognize them. It might be supposed that the modern painter has failed to achieve resemblance. But then some pictures of the 1860's are "poorly" painted, too, and the objects in them differ considerably from the corresponding objects outside them. And yet, whatever the differences, the very blunders of the traditional artist point toward the "human" object; they are downfalls on the way toward it and somehow equivalent to the orienting words "This is a cock" with which Cervantes lets the painter Orbanejo enlighten his public. In modern paintings the opposite happens. It is not that the painter is bungling and fails to render the natural (natural = human) thing because he deviates from it, but that these deviations point in a direction opposite to that which would lead to reality.

Far from going more or less clumsily toward reality, the artist is seen going against it. He is brazenly set on deforming reality, shattering its human aspect, dehumanizing it. With the things represented on traditional paintings we could have imaginary intercourse. Many a young Englishman has fallen in love with Gioconda. With the objects of modern pictures no intercourse is possible. By divesting them of their aspect of "lived" reality the artist has blown up the bridges and burned the ships that could have taken us back to our daily world. He leaves us locked up in an abstruse universe,

surrounded by objects with which human dealings are inconceivable, and thus compels us to improvise other forms of intercourse completely distinct from our ordinary ways with things. We must invent unheard-of gestures to fit those singular figures. This new way of life which presupposes the annulment of spontaneous life is precisely what we call understanding and enjoyment of art. Not that this life lacks sentiments and passions, but those sentiments and passions evidently belong to a flora other than that which covers the hills and dales of primary and human life. What those ultra-objects* evoke in our inner artist are secondary passions, specifically aesthetic sentiments.

It may be said that, to achieve this result, it would be simpler to dismiss human forms—man, house, mountain—altogether and to construct entirely original figures. But, in the first place, this is not feasible.† Even in the most abstract ornamental line a stubborn reminiscence lurks of certain "natural" forms. Secondly— and this is the crucial point—the art of which we speak is inhuman not only because it contains no things human, but also because it is an explicit act of dehumanization. In his escape from the human world the young artist cares less for the "*terminus ad quem,*" the startling fauna at which he arrives, than for the "*terminus a quo,*" the human aspect which he destroys. The question is not to paint something altogether different from

* "Ultraism" is one of the most appropriate names that have been coined to denote the new sensibility.

† An attempt has been made in this extreme sense—in certain works by Picasso—but it has failed signally.

a man, a house, a mountain, but to paint a man who resembles a man as little as possible; a house that preserves of a house exactly what is needed to reveal the metamorphosis; a cone miraculously emerging—as the snake from his slough—from what used to be a mountain. For the modern artist, aesthetic pleasure derives from such a triumph over human matter. That is why he has to drive home the victory by presenting in each case the strangled victim.

It may be thought a simple affair to fight shy of reality, but it is by no means easy. There is no difficulty in painting or saying things which make no sense whatever, which are unintelligible and therefore nothing. One only needs to assemble unconnected words or to draw random lines.* But to construct something that is not a copy of "nature" and yet possesses substance of its own is a feat which presupposes nothing less than genius.

"Reality" constantly waylays the artist to prevent his flight. Much cunning is needed to effect the sublime escape. A reversed Odysseus, he must free himself from his daily Penelope and sail through reefs and rocks to Circe's Faery. When, for a moment, he succeeds in escaping the perpetual ambush, let us not grudge him a gesture of arrogant triumph, a St. George gesture with the dragon prostrate at his feet.

* This was done by the dadaistic hoax. It is interesting to note again (see the above footnote) that the very vagaries and abortive experiments of the new art derive with a certain cogency from its organic principle, thereby giving ample proof that modern art is a unified and meaningful movement.

⟨ The works of art that the nineteenth century favored invariably contain a core of "lived" reality which furnishes the substance, as it were, of the aesthetic body. With this material the aesthetic process works, and its working consists in endowing the human nucleus with glamour and dignity. To the majority of people this is the most natural and the only possible setup of a work of art. Art is reflected life, nature seen through a temperament, representation of human destinies, and so on. But the fact is that our young artists, with no less conviction, maintain the opposite. Must the old always have the last word today while tomorrow infallibly the young win out? For one thing, let us not rant and rave. *"Dove si grida,"* Leonardo da Vinci warns us, *"no é vera scienza." "Neque lugere neque indignari sed intelligere,"* recommends Spinoza. Our firmest convictions are apt to be the most suspect, they mark our limits and our bonds. Life is a petty thing unless it is moved by the indomitable urge to extend its boundaries. Only in proportion as we are desirous of living more do we really live. Obstinately to insist on carrying on within the same familiar horizon betrays weakness and a decline of vital energies. Our horizon is a biological line, a living part of our organism. In times of fullness of life it expands, elastically moving in unison almost with our breathing. When the horizon stiffens it is because it has become fossilized and we are growing old.

It is less obvious than academicians assume that a

work of art must consist of human stuff which the Muses comb and groom. Art cannot be reduced to cosmetics. Perception of "lived" reality and perception of artistic form, as I have said before, are essentially incompatible because they call for a different adjustment of our perceptive apparatus. An art that requires such a double seeing is a squinting art. The nineteenth century was remarkably cross-eyed. That is why its products, far from representing a normal type of art, may be said to mark a maximum aberration in the history of taste. All great periods of art have been careful not to let the work revolve about human contents. The imperative of unmitigated realism that dominated the artistic sensibility of the last century must be put down as a freak in aesthetic evolution. It thus appears that the new inspiration, extravagant though it seems, is merely returning, at least in one point, to the royal road of art. For this road is called "will to style." But to stylize means to deform reality, to derealize; style involves dehumanization. And vice versa, there is no other means of stylizing except by dehumanizing. Whereas realism, exhorting the artist faithfully to follow reality, exhorts him to abandon style. A Zurbarán enthusiast, groping for the suggestive word, will declare that the works of this painter have "character." And character and not style is distinctive of the works of Lucas and Sorolla, of Dickens and Galdós. The eighteenth century, on the other hand, which had so little character was a past master of style.

MORE ABOUT
THE DEHUMANIZATION OF ART

❡ The young set has declared taboo any infiltration of human contents into art. Now, human contents, the component elements of our daily world, form a hierarchy of three ranks. There is first the realm of persons, second that of living beings, lastly there are the inorganic things. The veto of modern art is more or less apodictic according to the rank the respective object holds in this hierarchy. The first stratum, as it is most human, is most carefully avoided.

This is clearly discernible in music and in poetry. From Beethoven to Wagner music was primarily concerned with expressing personal feelings. The composer erected great structures of sound in which to accommodate his autobiography. Art was, more or less, confession. There existed no way of aesthetic enjoyment except by contagion. "In music," Nietzsche declared, "the passions enjoy themselves." Wagner poured into *Tristan and Isolde* his adultery with Mathilde Wesendonck, and if we want to enjoy this work we must, for a few hours, turn vaguely adulterous ourselves. That darkly stirring music makes us weep and tremble and melt away voluptuously. From Beethoven to Wagner all music is melodrama.

And that is unfair, a young artist would say. It means taking advantage of a noble weakness inherent in man which exposes him to infection from his neighbor's joys and sorrows. Such an infection is no mental

phenomenon; it works like a reflex in the same way as the grating of a knife upon glass sets the teeth on edge. It is an automatic effect, nothing else. We must distinguish between delight and titillation. Romanticism hunts with a decoy, it tampers with the bird's fervor in order to riddle him with the pellets of sounds. Art must not proceed by psychic contagion, for psychic contagion is an unconscious phenomenon, and art ought to be full clarity, high noon of the intellect. Tears and laughter are, aesthetically, frauds. The gesture of beauty never passes beyond smiles, melancholy or delighted. If it can do without them, better still. *"Toute maîtrise jette le froid"* (Mallarmé).

There is, to my mind, a good deal of truth in the young artist's verdict. Aesthetic pleasure must be a seeing pleasure. For pleasures may be blind or seeing. The drunken man's happiness is blind. Like everything in the world it has a cause, the alcohol; but it has no motive. A man who has won at sweepstakes is happy too, but in a different manner; he is happy "about" something. The drunken man's merriment is hermetically enclosed in itself, he does not know why he is happy. Whereas the joy of the winner consists precisely in his being conscious of a definite fact that motivates and justifies his contentment. He is glad because he is aware of an object that is in itself gladdening. His is a happiness with eyes and which feeds on its motive, flowing, as it were, from the object to the subject.*

* Causation and motivation are two completely different relations. The causes of our states of consciousness are not present in

Any phenomenon that aspires to being mental and not mechanical must bear this luminous character of intelligibility, of motivation. But the pleasure aroused by romantic art has hardly any connection with its content. What has the beauty of music—something obviously located without and beyond myself in the realm of sound—what has the beauty of music to do with that melting mood it may produce in me? Is not this a thorough confusion? Instead of delighting in the artistic object people delight in their own emotions, the work being only the cause and the alcohol of their pleasure. And such a *quid pro quo* is bound to happen whenever art is made to consist essentially in an exposition of "lived" realities. "Lived" realities are too overpowering not to evoke a sympathy which prevents us from perceiving them in their objective purity.

Seeing requires distance. Each art operates a magic lantern that removes and transfigures its objects. On its screen they stand aloof, inmates of an inaccessible world, in an absolute distance. When this derealization is lacking, an awkward perplexity arises: we do not know whether to "live" the things or to observe them.

Madame Tussaud's comes to mind and the peculiar uneasiness aroused by dummies. The origin of this uneasiness lies in the provoking ambiguity with which wax figures defeat any attempt at adopting a clear and consistent attitude toward them. Treat them as living

these states; science must ascertain them. But the motive of a feeling, of a volition, of a belief forms part of the act itself. Motivation is a conscious relation.

beings, and they will sniggeringly reveal their waxen secret. Take them for dolls, and they seem to breathe in irritated protest. They will not be reduced to mere objects. Looking at them we suddenly feel a misgiving: should it not be they who are looking at us? Till in the end we are sick and tired of those hired corpses. Wax figures are melodrama at its purest.

The new sensibility, it seems to me, is dominated by a distaste for human elements in art very similar to the feelings cultured people have always experienced at Madame Tussaud's, while the mob has always been delighted by that gruesome waxen hoax. In passing we may here ask ourselves a few impertinent questions which we have no intention to answer now. What is behind this disgust at seeing art mixed up with life? Could it be disgust for the human sphere as such, for reality, for life? Or is it rather the opposite: respect for life and unwillingness to confuse it with art, so inferior a thing as art? But what do we mean by calling art an inferior function—divine art, glory of civilization, *fine fleur* of culture, and so forth? As we were saying, these questions are impertinent; let us dismiss them.

In Wagner, melodrama comes to a peak. Now, an artistic form, on reaching its maximum, is likely to topple over into its opposite. And thus we find that in Wagner the human voice has already ceased to be the protagonist and is drowned in the cosmic din of the orchestra. However, a more radical change was to follow. Music had to be relieved of private sentiments and purified in an exemplary objectification. This was the deed

of Debussy. Owing to him, it has become possible to listen to music serenely, without swoons and tears. All the various developments in the art of music during these last decades move on the ground of the new ultra-worldly world conquered by the genius of Debussy. So decisive is this conversion of the subjective attitude into the objective that any subsequent differentiations appear comparatively negligible.* Debussy dehumanized music, that is why he marks a new era in the art of music.

The same happened in poetry. Poetry had to be disencumbered. Laden with human matter it was dragging along, skirting the ground and bumping into trees and house tops like a deflated balloon. Here Mallarmé was the liberator who restored to the lyrical poem its ethereal quality and ascending power. Perhaps he did not reach the goal himself. Yet it was he who gave the decisive order: shoot ballast.

For what was the theme of poetry in the romantic century? The poet informed us prettily of his private upper-middle-class emotions, his major and minor sorrows, his yearnings, his religious or political preoccupations, and, in case he was English, his reveries behind his pipe. In one way or another, his ambition was to enhance his daily existence. Thanks to personal genius, a halo of finer substance might occasionally surround the human core of the poem—as for instance

* A more detailed analysis of Debussy's significance with respect to romantic music may be found in the author's above quoted essay "Musicalia."

in Baudelaire. But this splendor was a by-product. All the poet wished was to be human.

"And that seems objectionable to a young man?" somebody who has ceased to be one asks with suppressed indignation. "What does he want the poet to be? A bird, an ichthyosaurus, a dodecahedron?"

I can't say. However, I believe that the young poet when writing poetry simply wishes to be a poet. We shall yet see that all new art (like new science, new politics—new life, in sum) abhors nothing so much as blurred borderlines. To insist on neat distinctions is a symptom of mental honesty. Life is one thing, art is another—thus the young set think or at least feel—let us keep the two apart. The poet begins where the man ends. The man's lot is to live his human life, the poet's to invent what is nonexistent. Herein lies the justification of the poetical profession. The poet aggrandizes the world by adding to reality, which is there by itself, the continents of his imagination. Author derives from *auctor*, he who augments. It was the title Rome bestowed upon her generals when they had conquered new territory for the City.

Mallarmé was the first poet in the nineteenth century who wanted to be nothing but a poet. He "eschewed"— as he said himself—"the materials offered by nature" and composed small lyrical objects distinct from the human fauna and flora. This poetry need not be "felt." As it contains nothing human, it contains no cue for emotion either. When a woman is mentioned it is "the woman no one"; when an hour strikes it is "the hour not

marked on dials." Proceeding by negatives, Mallarmé's verse muffles all vital resonance and presents us with figures so extramundane that merely looking at them is delight. Among such creatures, what business has the poor face of the man who officiates as poet? None but to disappear, to vanish and to become a pure nameless voice breathing into the air the words—those true protagonists of the lyrical pursuit. This pure and nameless voice, the mere acoustic carrier of the verse, is the voice of the poet who has learned to extricate himself from the surrounding man.

Wherever we look we see the same thing: flight from the human person. The methods of dehumanization are many. Those employed today may differ vastly from Mallarmé's; in fact, I am well aware that his pages are still reached by romantic palpitations. Yet just as modern music belongs to a historical unity that begins with Debussy, all new poetry moves in the direction in which Mallarmé pointed. The landmarks of these two names seem to me essential for charting the main line of the new style above the indentations produced by individual inspirations.

It will not be easy to interest a person under thirty in a book that under the pretext of art reports on the doings of some men and women. To him, such a thing smacks of sociology or psychology. He would accept it gladly if issues were not confused and those facts were told him in sociological and psychological terms. But art means something else to him.

Poetry has become the higher algebra of metaphors.

❰ The metaphor is perhaps one of man's most fruitful potentialities. Its efficacy verges on magic, and it seems a tool for creation which God forgot inside one of His creatures when He made him.

All our other faculties keep us within the realm of the real, of what is already there. The most we can do is to combine things or to break them up. The metaphor alone furnishes an escape; between the real things, it lets emerge imaginary reefs, a crop of floating islands.

A strange thing, indeed, the existence in man of this mental activity which substitutes one thing for another—from an urge not so much to get at the first as to get rid of the second. The metaphor disposes of an object by having it masquerade as something else. Such a procedure would make no sense if we did not discern beneath it an instinctive avoidance of certain realities.*

In his search for the origin of the metaphor a psychologist recently discovered to his surprise that one of its roots lies in the spirit of the taboo.† There was an age when fear formed the strongest incentive of man, an age ruled by cosmic terror. At that time a compulsion was felt to keep clear of certain realities which, on the other hand, could not be entirely avoided. The animal that was most frequent in the region and on which peo-

* More about metaphors may be found in the author's essay "Las dos grandes metáphoras" in *El Espectador* (Madrid, 1925), vol. IV, 153.

† Cf. Heinz Werner, *Die Ursprünge der Metapher*. Leipzig: Engelmann, 1919.

ple depended for food acquired the prestige of something sacred. Such a sanctification implied the idea that a person must not touch that animal with his hands. What then does the Indian Lilloeth do so that he can eat? He squats and folds his hands under his behind. This way he can eat, for hands folded under him are metaphorically feet. Here we have a trope in the form of action, a primordial metaphor preceding verbal imagery and prompted by a desire to get around a reality.

Since to primitive man a word is somehow identical with the thing it stands for, he finds it impossible to name the awful object on which a taboo has fallen. Such an object has to be alluded to by a word denoting something else and thus appears in speech vicariously and surreptitiously. When a Polynesian, who must not call by name anything belonging to the king, sees the torches lighted in the royal hut he will say: "The lightning shines in the clouds of heaven." Here again we have metaphorical elusion.

Once it is obtained in this tabooistic form, the instrument of metaphoric expression can be employed for many diverse purposes. The one predominant in poetry has aimed at exalting the real object. Similes have been used for decorative purposes, to embellish and to throw into relief beloved reality. It would be interesting to find out whether in the new artistic inspiration, where they fulfill a substantive and not a merely decorative function, images have not acquired a curious derogatory quality and, instead of ennobling and enhancing, be-

little and disparage poor reality. I remember reading a book of modern poetry in which a flash of lightning was compared to a carpenter's rule and the leafless trees of winter to brooms sweeping the sky. The weapon of poetry turns against natural things and wounds or murders them.

SURREALISM AND INFRAREALISM

❡ But the metaphor, though the most radical instrument of dehumanization, is certainly not the only one. There are many of varying scope.

The simplest may be described as a change of perspective. From the standpoint of ordinary human life things appear in a natural order, a definite hierarchy. Some seem very important, some less so, and some altogether negligible. To satisfy the desire for dehumanization one need not alter the inherent nature of things. It is enough to upset the value pattern and to produce an art in which the small events of life appear in the foreground with monumental dimensions.

Here we have the connecting link between two seemingly very different manners of modern art, the surrealism of metaphors and what may be called infrarealism. Both satisfy the urge to escape and elude reality. Instead of soaring to poetical heights, art may dive beneath the level marked by the natural perspective. How it is possible to overcome realism by merely putting too fine a point on it and discovering, lens in hand,

the micro-structure of life can be observed in Proust, Ramón Gómez de la Serna, Joyce.

Ramón can compose an entire book on bosoms—somebody has called him a new Columbus discovering hemispheres—or on the circus, or on the dawn, or on the Rastro and the Puerta del Sol. The procedure simply consists in letting the outskirts of attention, that which ordinarily escapes notice, perform the main part in life's drama. Giraudoux, Morand, etc., employ (in their several ways) the same aesthetic equipment.

That explains Giraudoux's and Morand's enthusiasm for Proust, as it explains in general the admiration shown by the younger set for a writer so thoroughly of another time. The essential trait Proust's amplitudinous novel may have in common with the new sensibility is this change of perspective: contempt for the old monumental forms of the soul and an unhuman attention to the micro-structure of sentiments, social relations, characters.

INVERSION

❰ In establishing itself in its own right, the metaphor assumes a more or less leading part in the poetical pursuit. This implies that the aesthetic intention has veered round and now points in the opposite direction. Before, reality was overlaid with metaphors by way of ornament; now the tendency is to eliminate the extrapoetical, or real, prop and to "realize" the metaphor, to make it

the *res poetica*. This inversion of the aesthetic process is not restricted to the use made of metaphors. It obtains in all artistic means and orders, to the point of determining—in the form of a tendency*—the physiognomy of all contemporary art.

The relation between our mind and things consists in that we think the things, that we form ideas about them. We possess of reality, strictly speaking, nothing but the ideas we have succeeded in forming about it. These ideas are like a belvedere from which we behold the world. Each new idea, as Goethe put it, is like a newly developed organ. By means of ideas we see the world, but in a natural attitude of the mind we do not see the ideas—the same as the eye in seeing does not see itself. In other words, thinking is the endeavor to capture reality by means of ideas; the spontaneous movement of the mind goes from concepts to the world.

But an absolute distance always separates the idea from the thing. The real thing always overflows the concept that is supposed to hold it. An object is more and other than what is implied in the idea of it. The idea remains a bare pattern, a sort of scaffold with which we try to get at reality. Yet a tendency resident in human nature prompts us to assume that reality is what we think of it and thus to confound reality and idea by taking in good faith the latter for the thing itself. Our yearning for reality leads us to an ingenuous idealiza-

* It would be tedious to warn at the foot of each page that each of the features here pointed out as essential to modern art must be understood as existing in the form of a predominant propensity, not of an absolute property.

tion of reality. Such is the innate predisposition of man.

If we now invert the natural direction of this process; if, turning our back on alleged reality, we take the ideas for what they are—mere subjective patterns—and make them live as such, lean and angular, but pure and transparent; in short, if we deliberately propose to "realize" our ideas—then we have dehumanized and, as it were, derealized them. For ideas are really unreal. To regard them as reality is an idealization, a candid falsification. On the other hand, making them live in their very unreality is—let us express it this way—realizing the unreal as such. In this way we do not move from the mind to the world. On the contrary, we give three-dimensional being to mere patterns, we objectify the subjective, we "worldify" the immanent.

A traditional painter painting a portrait claims to have got hold of the real person when, in truth and at best, he has set down on the canvas a schematic selection, arbitrarily decided on by his mind, from the innumerable traits that make a living person. What if the painter changed his mind and decided to paint not the real person but his own idea, his pattern, of the person? Indeed, in that case the portrait would be the truth and nothing but the truth, and failure would no longer be inevitable. In foregoing to emulate reality the painting becomes what it authentically is: an image, an unreality.

Expressionism, cubism, etc., are—in varying degree—attempts at executing this decision. From painting things, the painter has turned to painting ideas. He

shuts his eyes to the outer world and concentrates upon the subjective images in his own mind.

Notwithstanding its crudeness and the hopeless vulgarity of its subject, Pirandello's drama *Six Personages in Search of an Author* is, from the point of view of an aesthetic theory of the drama, perhaps one of the most interesting recent plays. It supplies an excellent example of this inversion of the artistic attitude which I am trying to describe. The traditional playwright expects us to take his personages for persons and their gestures for the indications of a "human" drama. Whereas here our interest is aroused by some personages as such—that is, as ideas or pure patterns.

Pirandello's drama is, I dare say, the first "drama of ideas" proper. All the others that bore this name were not dramas of ideas, but dramas among pseudo persons symbolizing ideas. In Pirandello's work, the sad lot of each of the six personages is a mere pretext and remains shadowy. Instead, we witness the real drama of some ideas as such, some subjective phantoms gesticulating in an author's mind. The artist's intent to dehumanize is unmistakable, and conclusive proof is given of the possibility of executing it. At the same time, this work provides a model instance for the difficulty of the average public to accommodate their vision to such an inverted perspective. They are looking for the human drama which the artist insists on presenting in an offhand, elusive, mocking manner putting in its place— that is, in the first place—the theatrical fiction itself. Average theater-goers resent that he will not deceive

them, and refuse to be amused by that delightful fraud of art—all the more exquisite the more frankly it reveals its fraudulent nature.

ICONOCLASM

❲ It is not an exaggeration to assert that modern paintings and sculptures betray a real loathing of living forms or forms of living beings. The phenomenon becomes particularly clear if the art of these last years is compared with that sublime hour when painting and sculpture emerge from Gothic discipline as from a nightmare and bring forth the abundant, world-wide harvest of the Renaissance. Brush and chisel delight in rendering the exuberant forms of the model—man, animal, or plant. All bodies are welcome, if only life with its dynamic power is felt to throb in them. And from paintings and sculptures organic form flows over into ornament. It is the epoch of the cornucopias whose torrential fecundity threatens to flood all space with round, ripe fruits.

Why is it that the round and soft forms of living bodies are repulsive to the present-day artist? Why does he replace them with geometric patterns? For with all the blunders and all the sleights of hand of cubism, the fact remains that for some time we have been well pleased with a language of pure Euclidean patterns.

The phenomenon becomes more complex when we remember that crazes of this kind have periodically re-

curred in history. Even in the evolution of prehistoric art we observe that artistic sensibility begins with seeking the living form and then drops it, as though affrighted and nauseated, and resorts to abstract signs, the last residues of cosmic or animal forms. The serpent is stylized into the meander, the sun into the swastica. At times, this disgust at living forms flares up and produces public conflicts. The revolt against the images of Oriental Christianism, the Semitic law forbidding representation of animals—an attitude opposite to the instinct of those people who decorated the cave of Altamira—doubtless originate not only in a religious feeling but also in an aesthetic sensibility whose subsequent influence on Byzantine art is clearly discernible.

A thorough investigation of such eruptions of iconoclasm in religion and art would be of high interest. Modern art is obviously actuated by one of these curious iconoclastic urges. It might have chosen for its motto the commandment of Porphyrius which, in its Manichaean adaptation, was so violently opposed by St. Augustine: *Omne corpus fugiendum est*—where *corpus*, to be sure, must be understood as "living body." A curious contrast indeed with Greek culture which at its height was so deeply in love with living forms.

NEGATIVE INFLUENCE OF THE PAST

❡ This essay, as I have said before, confines itself to delineating the new art by means of some of its distinguishing features. However, it is prompted by a curi-

osity of wider scope which these pages do not venture to satisfy but only wish to arouse in the reader; whereupon we shall leave him to his own meditations.

Elsewhere* I have pointed out that it is in art and pure science, precisely because they are the freest activities and least dependent on social conditions, that the first signs of any changes of collective sensibility become noticeable. A fundamental revision of man's attitude towards life is apt to find its first expression in artistic creation and scientific theory. The fine texture of both these matters renders them susceptible to the slightest breeze of the spiritual trade-winds. As in the country, opening the window of a morning, we examine the smoke rising from the chimney-stacks in order to determine the wind that will rule the day, thus we can, with a similar meteorologic purpose, study the art and science of the young generation.

The first step has been to describe the new phenomenon. Only now that this is done can we proceed to ask of which new general style of life modern art is the symptom and the harbinger. The answer requires an analysis of the causes that have effected this strange about-face in art. Why this desire to dehumanize? Why this disgust at living forms? Like all historical phenomena this too will have grown from a multitude of entangled roots which only a fine flair is capable of detecting. An investigation of this kind would be too serious a task to be attacked here. However, what other

* Cf. The author's book *The Modern Theme* (The C. W. Daniel Company, London: 1931), p. 26.

causes may exist, there is one which, though perhaps not decisive, is certainly very clear.

We can hardly put too much stress on the influence which at all times the past of art exerts on the future of art. In the mind of the artist a sort of chemical reaction is set going by the clash between his individual sensibility and already existing art. He does not find himself all alone with the world before him; in his relations with the world there always intervenes, like an interpreter, the artistic tradition. What will the reaction of creative originality upon the beauty of previous works be like? It may be positive or negative. Either the artist is in conformity with the past and regards it as his heritage which he feels called upon to perfect; or he discovers that he has a spontaneous indefinable aversion against established and generally acclaimed art. And as in the first case he will be pleased to settle down in the customary forms and repeat some of their sacred patterns, thus he will, in the second, not only deviate from established tradition but be equally pleased to give to his work an explicit note of protest against the time-honored norms.

The latter is apt to be overlooked when one speaks of the influence of the past on the present. That a work of a certain period may be modeled after works of another previous period has always been easily recognized. But to notice the negative influence of the past and to realize that a new style has not infrequently grown out of a conscious and relished antagonism to traditional styles seems to require somewhat of an effort.

As it is, the development of art from Romanticism to

this day cannot be understood unless this negative mood of mocking aggressiveness is taken into account as a factor of aesthetic pleasure. Baudelaire praises the black Venus precisely because the classical is white. From then on the successive styles contain an ever increasing dose of derision and disparagement until in our day the new art consists almost exclusively of protests against the old. The reason is not far to seek. When an art looks back on many centuries of continuous evolution without major hiatuses or historical catastrophes its products keep on accumulating, and the weight of tradition increasingly encumbers the inspiration of the hour. Or to put it differently, an ever growing mass of traditional styles hampers the direct and original communication between the nascent artist and the world around him. In this case one of two things may happen. Either tradition stifles all creative power—as in Egypt, Byzantium, and the Orient in general—or the effect of the past on the present changes its sign and a long epoch appears in which the new art, step by step, breaks free of the old which threatened to smother it. The latter is typical of Europe whose futuristic instinct, predominant throughout its history, stands in marked contrast to the irremediable traditionalism of the Orient.

A good deal of what I have called dehumanization and disgust for living forms is inspired by just such an aversion against the traditional interpretation of realities. The vigor of the assault stands in inverse proportion to the distance. Keenest contempt is felt for

nineteenth century procedures although they contain already a noticeable dose of opposition to older styles. On the other hand, the new sensibility exhibits a somewhat suspicious enthusiasm for art that is most remote in time and space, for prehistoric or savage primitivism. In point of fact, what attracts the modern artist in those primordial works is not so much their artistic quality as their candor; that is, the absence of tradition.

If we now briefly consider the question: What type of life reveals itself in this attack on past art? we come upon a strange and stirring fact. To assail all previous art, what else can it mean than to turn against Art itself? For what is art, concretely speaking, if not such art as has been made up to now?

Should that enthusiasm for pure art be but a mask which conceals surfeit with art and hatred of it? But, how can such a thing come about? Hatred of art is unlikely to develop as an isolated phenomenon; it goes hand in hand with hatred of science, hatred of State, hatred, in sum, of civilization as a whole. Is it conceivable that modern Western man bears a rankling grudge against his own historical essence? Does he feel something akin to the *odium professionis* of medieval monks —that aversion, after long years of monastic discipline, against the very rules that had shaped their lives?*

* It would be interesting to analyze the psychological mechanisms through which yesterday's art negatively affects the art of today. One is obvious: ennui. Mere repetition of a style has a blunting and tiring effect. In his *Principles of Art History; the Problem of the Development of Style in Later Art* (London: Bell, 1932) Heinrich Wölfflin mentions the power of boredom which

This is the moment prudently to lay down one's pen and let a flock of questions take off on their winged course.

DOOMED TO IRONY

⁋ When we discovered that the new style taken in its most general aspect is characterized by a tendency to eliminate all that is human and to preserve only the purely artistic elements, this seemed to betray a great enthusiasm for art. But when we then walked around the phenomenon and looked at it from another angle we came upon an unexpected grimace of surfeit or disdain. The contradiction is obvious and must be strongly stressed. It definitely indicates that modern art is of an ambiguous nature which, as a matter of fact, does not surprise us; for ambiguous have been all important issues of these current years. A brief analysis of the political development in Europe would reveal the same intrinsic ambiguity.

However, in the case of art, the contradiction between love and hatred for one and the same thing will appear somewhat mitigated after a closer inspection of present-day artistic production.

has ever again mobilized art and compelled it to invent new forms. And the same applies to literature, only more so. Cicero still said "*latine loqui*" for "speaking Latin"; but in the fifth century Apollinaris Sidonius resorted to "*latialiter insusurrare*." For too many centuries the same had been said with the same words.

The first consequence of the retreat of art upon itself is a ban on all pathos. Art laden with "humanity" had become as weighty as life itself. It was an extremely serious affair, almost sacred. At times—in Schopenhauer and Wagner—it aspired to nothing less than to save mankind. Whereas the modern inspiration—and this is a strange fact indeed—is invariably waggish. The waggery may be more or less refined, it may run the whole gamut from open clownery to a slight ironical twinkle, but it is always there. And it is not that the content of the work is comical—that would mean a relapse into a mode or species of the "human" style—but that, whatever the content, the art itself is jesting. To look for fiction as fiction—which, we have said, modern art does—is a proposition that cannot be executed except with one's tongue in one's cheek. Art is appreciated precisely because it is recognized as a farce. It is this trait more than any other that makes the works of the young so incomprehensible to serious people of less progressive taste. To them modern painting and music are sheer "farce"—in the bad sense of the word—and they will not be convinced that to be a farce may be precisely the mission and the virtue of art. A "farce" in the bad sense of the word it would be if the modern artist pretended to equal status with the "serious" artists of the past, and a cubist painting expected to be extolled as solemnly and all but religiously as a statue by Michelangelo. But all he does is to invite us to look at a piece of art that is a joke and that essentially makes fun of itself. For this is what the facetious quality of the

modern inspiration comes down to. Instead of deriding other persons or things—without a victim no comedy—the new art ridicules art itself.

And why be scandalized at this? Art has never shown more clearly its magic gift than in this flout at itself. Thanks to this suicidal gesture art continues to be art, its self-negation miraculously bringing about its preservation and triumph.

I much doubt that any young person of our time can be impressed by a poem, a painting, or a piece of music that is not flavored with a dash of irony.

Nor is this ironical reflection of art upon itself entirely new as an idea and a theory. In the beginning of the last century a group of German romanticists, under the leadership of the two brothers Schlegel, pronounced irony the foremost aesthetic category, their reasons being much the same as those of our young artists. Art has no right to exist if, content to reproduce reality, it uselessly duplicates it. Its mission is to conjure up imaginary worlds. That can be done only if the artist repudiates reality and by this act places himself above it. Being an artist means ceasing to take seriously that very serious person we are when we are not an artist.

This inevitable dash of irony, it is true, imparts to modern art a monotony which must exasperate patience herself. But be that as it may, the contradiction between surfeit and enthusiasm now appears resolved. The first is aroused by art as a serious affair, the second is felt for art that triumphs as a farce, laughing off everything, itself included—much as in a system of mirrors

which indefinitely reflect one another no shape is ulti-
mate, all are eventually ridiculed and revealed as pure
images.

ART A THING
OF NO CONSEQUENCE

❲ All we have ascertained so far will now appear in-
tegrated in the most acute, serious, and deep-seated
symptom shown by modern art—a strange feature, in-
deed, and which requires cautious consideration. What
I mean is difficult to express for several reasons, but
mainly because it is a matter of accurate formulation.

To the young generation art is a thing of no conse-
quence. —The sentence is no sooner written than it
frightens me since I am well aware of all the different
connotations it implies. It is not that to any random
person of our day art seems less important than it
seemed to previous generations, but that the artist him-
self regards his art as a thing of no consequence. But
then again this does not accurately describe the situa-
tion. I do not mean to say that the artist makes light of
his work and his profession; but they interest him pre-
cisely because they are of no transcendent importance.
For a real understanding of what is happening let us
compare the role art is playing today with the role it
used to play thirty years ago and in general throughout
the last century. Poetry and music then were activities
of an enormous caliber. In view of the downfall of re-

ligion and the inevitable relativism of science, art was expected to take upon itself nothing less than the salvation of mankind. Art was important for two reasons: on account of its subjects which dealt with the profoundest problems of humanity, and on account of its own significance as a human pursuit from which the species derived its justification and dignity. It was a remarkable sight, the solemn air with which the great poet or the musical genius appeared before the masses— the air of a prophet and founder of religion, the majestic pose of a statesman responsible for the state of the world.

A present-day artist would be thunderstruck, I suspect, if he were trusted with so enormous a mission and, in consequence, compelled to deal in his work with matters of such scope. To his mind, the kingdom of art commences where the air feels lighter and things, free from formal fetters, begin to cut whimsical capers. In this universal pirouetting he recognizes the best warrant for the existence of the Muses. Were art to redeem man, it could do so only by saving him from the seriousness of life and restoring him to an unexpected boyishness. The symbol of art is seen again in the magic flute of the Great God Pan which makes the young goats frisk at the edge of the grove.

All modern art begins to appear comprehensible and in a way great when it is interpreted as an attempt to instill youthfulness into an ancient world. Other styles must be interpreted in connection with dramatic social or political movements, or with profound religious and

philosophical currents. The new style only asks to be linked to the triumph of sports and games. It is of the same kind and origin with them.

In these last few years we have seen almost all caravels of seriousness founder in the tidal wave of sports that floods the newspaper pages. Editorials threaten to be sucked into the abyss of their headlines, and across the surface victoriously sail the yachts of the regattas. Cult of the body is an infallible symptom of a leaning toward youth, for only the young body is lithe and beautiful. Whereas cult of the mind betrays the resolve to accept old age, for the mind reaches plenitude only when the body begins to decline. The triumph of sport marks the victory of the values of youth over the values of age. Note in this context the success of the motion picture, a preeminently corporeal art.

·In my generation the manners of old age still enjoyed great prestige. So anxious were boys to cease being boys that they imitated the stoop of their elders. Today children want to prolong their childhood, and boys and girls their youth. No doubt, Europe is entering upon an era of youthfulness.

Nor need this fact surprise us. History moves in long biological rhythms whose chief phases necessarily are brought about not by secondary causes relating to details but by fundamental factors and primary forces of a cosmic nature. It is inconceivable that the major and, as it were, polar differences inherent in the living organism—sex and age—should not decisively mold the profile of the times. Indeed, it can be easily observed that

history is rhythmically swinging back and forth between these two poles, stressing the masculine qualities in some epochs and the feminine in others, or exalting now a youthful deportment and then again maturity and old age.

The aspect European existence is taking on in all orders of life points to a time of masculinity and youthfulness. For a while women and old people will have to cede the rule over life to boys; no wonder that the world grows increasingly informal.

All peculiarities of modern art can be summed up in this one feature of its renouncing its importance—a feature which, in its turn, signifies nothing less than that art has changed its position in the hierarchy of human activities and interests. These activities and interests may be represented by a series of concentric circles whose radii measure the dynamic distances from the axis of life where the supreme desires are operating. All human matters—vital and cultural—revolve in their several orbits about the throbbing heart of the system. Art which—like science and politics—used to be very near the axis of enthusiasm, that backbone of our person, has moved toward the outer rings. It has lost none of its attributes, but it has become a minor issue.

The trend toward pure art betrays not arrogance, as is often thought, but modesty. Art that has rid itself of human pathos is a thing without consequence—just art with no other pretenses.

CONCLUSION

⟨ Isis *myrionoma*, Isis of the ten thousand names, the Egyptians called their goddess. And a thing with ten thousand names all reality is, in a way. Its components and its facets are countless. Is it not brazen to attempt a definition of any thing, of the humblest thing, with a few names? A stroke of luck it would be if the attributes here pointed out among an infinite number were in fact the decisive ones. The odds are particularly poor since the object is a nascent reality which just begins its course through space.

Thus chances are that this attempt to analyze modern art is full of errors. Now that I am about to conclude it the place it has been taking up in my mind is filled with the hope that others may tackle these problems more successfully. Among many tongues may be divided the calling of the ten thousand names.

But it would not mean improving upon my errors if one tried to correct them by pointing out this or that particular feature omitted in my analysis. Artists are apt to make this mistake when, speaking of their art, they fail to take the step back that affords an ample view of the facts. There can be no doubt that the best approximation to truth is contrived by a formula that in one unified, harmonious turn encompasses the greatest number of particular facts—like a loom which with one stroke interlaces a thousand threads.

I have been moved exclusively by the delight of trying to understand—and neither by ire nor by enthusi-

asm. I have sought to ascertain the meaning of the new intents of art and that, of course, presupposes an attitude of preconceived benevolence. But is it possible to approach a subject in another mind and not condemn it to barrenness?

It may be said that the new art has so far produced nothing worth while, and I am inclined to think the same. I have proposed to extract from the work of the young the intention which is the juicy part, and I have disregarded the realization. Who knows what may come out of this budding style? The task it sets itself is enormous; it wants to create from nought. Later, I expect, it will be content with less and achieve more.

But whatever their shortcomings, the young artists have to be granted one point: there is no turning back. All the doubts cast upon the inspiration of those pioneers may be justified, and yet they provide no sufficient reason for condemning them. The objections would have to be supplemented by something positive: a suggestion of another way for art different from dehumanization and yet not coincident with the beaten and worn-out paths.

It is easy to protest that it is always possible to produce art within the bounds of a given tradition. But this comforting phrase is of no use to the artist who, pen or chisel in hand, sits waiting for a concrete inspiration.

Translated from the Spanish by Helene Weyl

NOTES ON THE NOVEL

DECLINE OF THE NOVEL

*P*ublishers complain that novels do not sell well, and it is true that the reading public buys fewer novels while the demand for books of a theoretical character is relatively increasing. This statistical fact, even if there were no more intrinsic reasons, would suffice to make us suspect that something is amiss with the literary genre of the novel. When I hear a friend, particularly if he is a young writer, calmly announce that he is working on a novel I am appalled, and I feel that in his case I should be trembling in my boots. Perhaps I am wrong, but I cannot help scenting behind such an equanimity an alarming dose of incomprehension. To produce a good novel has always been a difficult thing. But while, before, it was enough to have talent the difficulty has now grown immeasurably, for to be a gifted novelist is no longer a guaranty for producing a good novel.

Unawareness of this fact is one component of the aforementioned incomprehension. Anyone who gives a little thought to the conditions of a work of art must admit that a literary genre may wear out. One cannot dismiss the subject by comfortably assuming that artistic creation depends on nothing but the artist's personal power called inspiration or talent—in which case decadence of a genre would be due exclusively to an accidental lack of talents, and the sudden appearance of a man of genius would at any time automatically turn the tide. Better beware of notions like genius and inspiration; they are a sort of magic wand and should

be used sparingly by anybody who wants to see things clearly. Imagine a woodsman, the strongest of woodsmen, in the Sahara desert. What good are his bulging muscles and his sharp ax? A woodsman without woods is an abstraction. And the same applies to artists. Talent is but a subjective disposition that is brought to bear upon a certain material. The material is independent of individual gifts; and when it is lacking genius and skill are of no avail.

Just as every animal belongs to a species, every literary work belongs to a genre. (The theory of Benedetto Croce who denies the existence of literary forms in this sense has left no trace in aesthetics.) A literary genre, the same as a zoological species, means a certain stock of possibilities; and since in art only those possibilities count which are different enough not to be considered replicas of one another, the resources of a literary genre are definitely limited. It is erroneous to think of the novel—and I refer to the modern novel in particular— as of an endless field capable of rendering ever new forms. Rather it may be compared to a vast but finite quarry. There exist a definite number of possible themes for the novel. The workmen of the primal hour had no trouble finding new blocks—new characters, new themes. But present-day writers face the fact that only narrow and concealed veins are left them.

With this stock of objective possibilities, which is the genre, the artistic talent works, and when the quarry is worked out talent, however great, can achieve nothing. Whether a genre is altogether done for can, of course,

never be decided with mathematical rigor; but it can at times be decided with sufficient practical approximation. At least, that the material is getting scarce may appear frankly evident.

This, I believe, is now happening to the novel. It has become practically impossible to find new subjects. Here we come upon the first cause of the enormous difficulty, an objective not a personal difficulty, of writing an acceptable novel at this advanced stage.

During a certain period novels could thrive on the mere novelty of their subjects which gratuitously added an induced current, as it were, to the value proper of the material. Thus many novels seemed readable which we now think a bore. It is not for nothing that the novel is called "novel." The difficulty of finding new subjects is accompanied by another, perhaps more serious, dilemma. As the store of possible subjects is more and more depleted the sensibility of the reading public becomes subtler and more fastidious. Works that yesterday would still have passed, today are deemed insipid. Not only is the difficulty of finding new subjects steadily growing, but ever "newer" and more extraordinary ones are needed to impress the reader. This is the second cause of the difficulty with which the genre as such is faced in our time.

Proof that the present decline is due to more fundamental causes than a possibly inferior quality of contemporary novels is given by the fact that, as it becomes more difficult to write novels, the famous old or classical

ones appear less good. Only a very few have escaped drowning in the reader's boredom.

This development is inevitable and need not dishearten the novelists. On the contrary; for they themselves are bringing it about. Little by little they train their public by sharpening the perception, and refining the taste, of their readers. Each work that is better than a previous one is detrimental to this and all others of the same level. Triumph cannot help being cruel. As the victor wins the battle at the cost of smashing the foe, thus the superior work automatically becomes the undoing of scores of other works that used to be highly thought of.

In short, I believe that the genre of the novel, if it is not yet irretrievably exhausted, has certainly entered its last phase, the scarcity of possible subjects being such that writers must make up for it by the exquisite quality of the other elements that compose the body of a novel.

AUTOPSY

❲ It cannot be denied that to us the great Balzac, save for one or two of his books, makes rather difficult reading. Our perceptive apparatus, used to more distinct and genuine spectacles, detects at once the conventional, artificial and à-peu-près complexion of the world of the *Human Comedy*. Were I asked why I find fault with Balzac I should answer: Because he is a dauber.

What distinguishes the dauber from the good painter? That on the latter's painting the object it represents is there in person, as it were, in the fullness of its being, in self-presence. Whereas the former, instead of presenting the object itself, sets down on his canvas only a few feeble and unessential allusions to it. The longer we look at his work, the clearer it becomes that the object is not there.

This difference between self-presence and mere allusion seems to me decisive in all art but very specially in the novel.

The subject of *Le rouge et le noir* could be told in a few dozen words. What is the difference between such a report and the novel itself? Certainly not the style. The crucial point is that when we say: "Madame Renal falls in love with Julien Sorel" we merely allude to this fact while Stendhal presents it in its immediate and patent reality.

Now, an examination of the evolution of the novel from its beginnings to our day reveals that, from being pure narration which but alludes, the novel has advanced to strict presentation. At first, the narrative as such kept the reader amused through the novelty of the subject. He was as delighted to listen to the hero's adventures as we are to hear what has happened to a person we love. But soon adventures by themselves lose attraction, and what then pleases is not so much the fortunes of the personages as their self-presence. We enjoy seeing those people before us and being admitted to their inner life, understanding them, and living im-

mersed in their world or atmosphere. From being narrative and indirect the novel has become direct and descriptive. The best word would be "presentative." The imperative of the novel is autopsy. No good telling us what a person is, we want to see with our own eyes.

Analyze such ancient novels as have survived in the appreciation of responsible readers, and it will appear that they all use the autoptic method. Above all *Don Quixote*. Cervantes fills all our senses with the genuine presence of his personages. We listen to their true conversations, we see their actual movements. Stendhal's greatness derives from the same cause.

NO DEFINITIONS

(We want to see the life of the figures in a novel, not to be told it. Any reference, allusion, narration only emphasizes the absence of what it alludes to. Things that are there need not be related.

Hence one of the major errors a novelist can commit consists in attempting to define his personages.

It is the task of science to work out definitions. All scientific endeavor lastly consists in the systematic effort to leave behind the object and to arrive at its definition. Now, a definition is nothing if not a series of concepts, and a concept is nothing else than a mental allusion to an object. The concept "red" contains no red; it is merely a movement of the mind toward the

color of this name, a sign pointing in the
this color.

It has been said by Wundt, if I remember ...
the most primitive form of a concept is the point...
gesture of the index finger. An infant still tries to take
hold of any object that enters his field of vision because
his undeveloped sense of perspective prevents him from
judging distances. After many failures he gives up and
contents himself with indicating the object with his out-
stretched hand—a symbolic capture. The true function
of concepts is to point or to indicate. Science is con-
cerned not with things but with the system of signs it
can substitute for things.

Art, on the other hand, urged by a magnificent im-
pulse to see, turns from the conventional signs to the
things themselves. There is a good deal of truth in
Fiedler's assertion that the aim of painting is to furnish
a fuller and completer view of things than can be ob-
tained in the ordinary intercourse with them.

The same, I believe, applies to the novel. In its be-
ginnings the plot may have seemed to form its most im-
portant part. Later it appeared that what really matters
is not the story which is told but that the story, what-
ever it might be, should be told well. From our present-
day standpoint the primitive novel seems more narra-
tive than the modern. However, this impression may
have to be revised. Perhaps a primitive reader resem-
bled a child in that he was capable of seeing in a few
lines, in a bare pattern the integral object with vigorous
presence. (Primitive sculpture and certain new psycho-

logical discoveries of great importance corroborate this belief.) In that case the novel would, strictly speaking, not have changed; its present descriptive, or rather presentative, form would merely be the means that had to be used in order to produce in a limp sensibility the same effect which in more springy souls had been obtained by narration.

When I read in a novel "John was peevish" it is as though the writer invited me to visualize, on the strength of his definition, John's peevishness in my own imagination. That is to say, he expects me to be the novelist. What is required, I should think, is exactly the opposite: that he furnish the visible facts so that I obligingly discover and define John to be peevish. A novelist must proceed in the same way as the impressionistic painters who set down on the canvas such elements as the spectator needs for seeing an apple, and leave it to him to give to this material the finishing touches. Hence the fresh taste of all impressionistic painting. We seem to see the objects of the picture in a perpetual *status nascendi*. In the career of every thing there are two moments of supreme drama: birth and death—*status nascens* and *status evanescens*. Nonimpressionistic painting, superior though it may be in other respects, suffers from one shortcoming: that it presents its objects altogether finished, mummified and, as it were, past. That actuality, that existence in the present tense, which things possess in impressionistic pictures is irremediably missing.

⟨ Hence the present-day novel must be the opposite of a story. A story relates events; the accent is on action. The fresh mind of a child is interested in adventure as such—perhaps, as we were saying, because the child sees in palpable presence what our imagination is too weak to visualize. Adventures do not interest us; or at least, they interest only the child that, as a somewhat barbarous residue, we all carry inside. The rest of our person is not susceptible to the mechanical thrill of, say, a dime novel; and so we feel, after having finished reading such products, a bad taste in our mouth as though we had indulged in a base pleasure. It is not easy nowadays to invent adventures capable of stirring the superior portion of our sensibility.

Action thus becomes a mere pretext—the string, as it were, that makes the beads into a necklace. Why that string cannot be dispensed with, will appear later on. At this point I wish to draw attention to the fact that when a novel bores us it is not, as an insufficient analysis may lead us to believe, because "its subject is uninteresting." If that were so we might as well declare the entire species dead and buried. For the impossibility of inventing new "interesting subjects" is all too patent.

No, when we are fascinated by a novel it is not because of its subject, not because we are curious to know what happened to Mr. So-and-so. The subject of any novel can be told in a few words and in this form holds no interest. A summary narration is not to our taste;

we want the novelist to linger and to grant us good long looks at his personages, their being, and their environment till we have had our fill and feel that they are close friends whom we know thoroughly in all the wealth of their lives. That is what makes of the novel an essentially slow-moving genre, as either Goethe or Novalis observed. I will go even further and say that today the novel is, and must be, a sluggish form—the very opposite therefore of a story, a "serial," or a thriller.

I have sometimes tried to explain the pleasure—a mild pleasure, to be sure—aroused by certain American films that consist of a long series of episodes. (But the word "episode" is absurd; a work made of episodes would be like a meal composed of side-dishes.) And I found to my great surprise that I felt entertained not by the stupid subject but by the personages themselves. A film in which the detective and the young American girl are attractive may go on indefinitely and never become boring. It does not matter what they do; we simply enjoy watching them. They interest us not because of what they are doing; rather the opposite, what they do interests us because it is they who do it.

Let the reader recall the great novels of former days that have lived up to the high standards of our time, and he will observe that his attention is turned to the personages themselves, not to their adventures. We are fascinated by Don Quixote and Sancho, not by what is happening to them. In principle, a *Don Quixote* as great as the original is conceivable in which the knight

and his servant go through entirely different experiences. And the same holds for Julien Sorel or David Copperfield.

FUNCTION AND SUBSTANCE

❦ Our interest has shifted from the plot to the figures, from actions to persons. Now, this transference—let it be noted parenthetically—finds a counterpart in what has, these last twenty years, been happening in physics and, above all, in philosophy. From Kant to about 1900 we observe a determinate tendency in theoretical thought to eliminate substances and to replace them by functions. In Greece and in the Middle Ages it was believed that *operari sequitur esse*—actions follow, and derive from, being. The nineteenth century may be said to have established the opposite principle: *esse sequitur operari*—the being of a thing is nothing else than the sum total of its actions and functions.

Should we, by any chance, now be again in the process of turning from action to the person, from function to substance? Such a transition would be indicative of an emerging classicism.

But this question deserves more comment, and it invites us to seek further orientation through a comparison of the classical French theater with the indigenous Spanish theater.

❴ Not many things illuminate the finer points of the diversity of French and Spanish destinies so well as the difference of structure between the classical French theater and the indigenous Spanish theater. I do not call the latter classical; for, without detriment to any of its other virtues, the character of classicism must be denied it. The Spanish theater is popular; and nothing in history, as far as I can see, has ever been classical and popular at once. The French tragedy, on the other hand, is an art for aristocrats. Thus it already differs from the Spanish regarding the class of people to which it addresses itself. Furthermore, its aesthetic intention is approximately the opposite of that of our popular playwrights. This must, of course, be understood as referring to both styles in their totality; either may admit of exceptions which are, as always, required to prove the rule.

In French tragedies, action is reduced to a minimum. Not only in the sense of the three unities (we shall yet see how important these are to the novel "that has to be written") but also in so far as the story that is told is cut down to the smallest size. Our theater amasses whatever adventures and changes of fortune it can possibly think of; one feels that the author has to entertain an audience already stirred up by a life of new and perilous experiences. The French tragedian wants to set down on the canvas of a well-known "history," which in itself holds no longer any dramatic interest, three or

four significant motives. Mere physical adventures he rather avoids; the events of outer life serve only to present certain inner problems. The author and his audience enjoy not so much the passions and the consequent dramatic entanglements of the personages as the analysis of those passions; whereas in the Spanish theater psychological anatomy of sentiments and characters is infrequent or at least unimportant. Sentiments and characters are taken from without as a whole and used as a springboard from which the drama or adventure takes off for its headlong leap. Anything else would have bored the audience of a Spanish *corral*, an audience of simple souls given to passion rather than to contemplation.

However, psychological analysis is not the last aim of French tragedies; it serves as a vehicle for another purpose which manifestly relates the French theater to Greek and Roman theater. (Seneca's influence on the classical French drama can hardly be overrated.) The aristocratic audience enjoys the exemplary and normative character of the tragic happenings. They go to the theater not to be stirred by Athalie's or Phèdre's anguish but to feel elated by the model deportment of those great-hearted figures. In the last instance, French theater is ethical contemplation, not vital emotion like the Spanish. What it presents is not a series of ethically neutral incidents but an exemplary type of reaction, a repertory of normative attitudes in the supreme crises of life. The personages are heroes, exalted characters, prototypes of magnanimity. There appear on this scene

only kings and peers—human beings who, exempt from the common urgencies of life, can freely devote their exuberant energies to purely moral conflicts. Even if we did not know the French society of that time, those tragedies would suggest an audience of people preoccupied with the high forms of seemliness and with their own perfection. The style is measured and of a noble tenor; it admits of neither coarseness, which may be so enlivening, nor utter frenzy. Passion never loses control of itself; proceeding with meticulous correctness of form, it keeps within the bounds of poetical, urbane, and even grammatical laws. French tragic art is the art of not letting fly, of always subjecting word and gesture to the highest regulative norm. In brief, French tragedies reveal that same will to selection and deliberate refinement that has, generation after generation, mellowed French life and French people.

In every order of life, abandonment is characteristic of the popular spirit. Popular religions have always reveled in orgiastic rites, and their excesses have always been opposed by the religious feeling of select minds. Brahmans fight against magic, Confucian mandarins against Taoistic superstition, Catholic councils against mystic ecstasy. Let us sum up these two antagonistic vital attitudes by saying that for the one, the noble and exacting one, ideal life consists in self-control, while to the other, the popular, to live means to surrender to the surge of emotion and to seek unconsciousness and frenzy in passion, orgies, or alcohol.

The Spanish public found something of the second

kind in the fiery plays our poets produced. And this confirms rather unexpectedly the condition of a people of "people" that, in an earlier book,* I have maintained to be discernible throughout the history of Spain. Not selection and measure, but passion and abandonment. No doubt, this thirst for strong brew is not conducive to greatness. I am not now concerned with considering the value of races and styles but with briefly adumbrating two contrary temperaments.

In general, the personalities of the men and women in Spanish plays remain blurred. What is interesting about them is not their characters but that they are seen roving through the wide world, tossed about by the whirlwind of adventure. Disheveled ladies lost in the Sierras, who yesterday appeared in grand attire in the soft light of drawing rooms and tomorrow, masked as Moors, may sail into the port of Constantinople. Sudden infatuations, as though by witchery, of burning hearts without gravity. That was what attracted our forefathers. In a delightful essay, Azorín describes a theatrical performance in the *corral* of an old Spanish village. The chivalrous lover, his life hanging by a thread, uses the most precarious moment to propose to his lady in flashy verse sparkling like torches with a wonderful rhetoric full of baroque flourishes and laden with images through which the entire flora and fauna is moving—that rhetoric which in sculpture engenders the post-Renaissance consoles with their trophies, their

* Cf. the author's book *Invertebrate Spain*. New York: W. W. Norton, 1937.

fruits, their pennants, and their heads of goats and rams. At this moment the dark eyes of one of the spectators, a scholar in his fifties, begin to burn in his waxen face, and with a nervous hand he caresses his grizzled goatee. This paragraph of Azorín's has taught me more about the Spanish theater than all the books I have read.* Inflammable matter the Spanish theater was—that is to say, a thing as distinct as possible from the norm of perfection the French theater aspired to be. Not for the sake of watching noble souls behave exemplarily did the good Castilian go to see the famous play, but to be swept off his feet and to get drunk on the potent draught of the adventures and ordeals of the personages. Over the intricate and varied pattern of the intrigue the poet poured his elaborate volubility—a profusion of glittering metaphors expressed in a vocabulary of darkest shadows alternating with brilliant light, a vocabulary reminiscent of the altar-pieces of that same century. Added to the conflagration of passionate destinies the audience found an imagination all aflame in the fireworks of Lope's and Calderón's quatrains.

The substance of the pleasure contained in our theater is of the same Dionysian kind with the mystic raptures of seventeenth century monks and nuns, those sublime indulgers in ecstasy. Not a grain of contemplation. Contemplation requires a cool head and a certain distance between the object and oneself. When we wish

* Cf. Américo Castro's introduction to the plays of Tirso de Molina, Clásicos Castellanos, Ediciones de la Lectura, Madrid.

to watch a torrent, the first thing to see to is that we are not swept away by it.

Two opposite artistic intentions, we thus find, are operating in these two theaters. In the Castilian drama the stress is on action, on destinies rich in vicissitudes and, at the same time, on the lyrical embellishment of ornate verse. In the French tragedy the essential thing is the personages themselves and their exemplary and paradigmatic nature. That is why Racine's work impresses us as cold, a monochrome. We feel ushered into a garden where some statues converse and, by displaying the very model of behavior, arouse our admiration to the point of boredom. Lope de Vega's work, on the other hand, is reminiscent of painting rather than sculpture. A vast canvas, now luminous now murky, on which all the figures shine with life and color, noblemen and commoners, archbishops and sea-captains, queens and country lasses, a restless, garrulous, exuberant, extravagant lot, madly swirling about like infusoria in a drop of water. To get a good view of the magnificent mass of the Spanish theater one must not open one's eyes wide as though following the pure line of a profile, but rather keep them half shut with a painter's gesture, with the gesture of Velázquez looking at the Meninas, the dwarfs, and the royal couple.

This point of view, it seems to me, affords the best angle under which to behold our theater today. The experts in Spanish literature—I know very little of it—ought to adopt it; it may prove fruitful and direct the

analysis toward the true values of that immense poetical crop.

My purpose here was merely to oppose an art of figures to an art of adventures. For I have a notion that in our time the novel of high style must turn from the latter to the former. Instead of constructing interesting plots—which is practically impossible—it must invent interesting characters.

DOSTOEVSKI AND PROUST

(While other great names are setting, carried down into oblivion by the mysterious revolution of the times, that of Dostoevski has established itself firmly in the zenith. Perhaps the present fervent admiration of his work is a trifle exaggerated, and I would rather reserve my judgment for a serener hour. At any rate, he has escaped from the general shipwreck of nineteenth century novels. But the reasons usually given to explain his triumph and his ability to survive seem to me erroneous. The interest his novels arouse is attributed to their material: the mysteriously dramatic action, the utterly pathological character of the personages, the exotic quality of those Slavic souls so different in their turbulent intricacy from our clear and neat dispositions. All this may contribute to the pleasure we draw from Dostoevski; only it is not sufficient reason. Moreover, there is a certain questionable quality to these features that makes them as well suited to repelling as to attracting

us. We remember that those novels used to leave us with a mingled feeling of pleasure and uneasy confusion.

The material never saves a work of art, the gold it is made of does not hallow a statue. A work of art lives on its form, not on its material; the essential grace it emanates springs from its structure, from its organism. The structure forms the properly artistic part of the work, and on it aesthetic and literary criticism should concentrate. If too much stress is laid on the subject of a painting or a poem, sensitive nerves smell the Philistine. No doubt, as there is no life without chemical processes, thus there is no work of art without a subject. Just as life cannot be reduced to chemistry but begins to be life only when it has imposed upon the chemical laws other original processes of a new and more complex order, so the work of art is what it is thanks to the form it imposes upon the material or subject.

I have often wondered why even experts find it difficult to recognize that form, which to the uninitiated may seem abstract and inefficient, is the true substance of art. The author's or the critic's point of view cannot be the same as that of the unqualified reader who is concerned exclusively with the ultimate and total effect the work has on him and does not care to analyze the genesis of his pleasure.

As it is, much has been said about what is going on in Dostoevski's novels and very little about their form. The extraordinary quality of the events and emotions this formidable writer describes has fascinated the critics and prevented them from penetrating into what,

at first sight, seems accidental and extrinsic but in reality forms the essence of the work: the structure of the novel as such. Hence a curious optical delusion. The turbulent, wayward character of his personages is ascribed to Dostoevski himself, and the novelist is looked upon as one more figure in his own novels—which indeed seem begotten in an hour of demoniacal ecstasy by some nameless elemental power, akin to the thunder and brother of the winds.

But all this is mere fancy. An alert mind may indulge in such colorful pictures but will soon dismiss them for the sake of clear ideas. It may be that the man Dostoevski was a poor epileptic or, if one so desires, a prophet. But the novelist Dostoevski was an *homme de lettres*, a conscientious craftsman of a sublime craft, and nothing else. Many a time have I tried in vain to convince Pío Baroja that Dostoevski was, above all, a past master of novelistic technique and one of the greatest innovators of the form of the novel.

There is no better example of what I have called the sluggish character of the genre. Dostoevski's books are almost all extremely long. But the story that is told is usually quite short. Sometimes it takes two volumes to describe what happens in three days, indeed, in a few hours. And yet, is there anything more intense? It is an error to believe that intensity is achieved through an accumulation of occurrences. Just the opposite; the fewer the better, providing they are detailed, i.e., "realized." Here, as in many other instances, the *multum non multa* applies. Density is obtained not by piling ad-

venture upon adventure but by drawing out each incident through a copious presentation of its minutest components.

The concentration of the plot in time and space, so characteristic of Dostoevski's technique, brings to mind, in an unexpected sense, the venerable unities of classical tragedy. This aesthetic rule, which calls for moderation and restraint, now appears as an efficient means of bringing about the inner density, the high pressure, as it were, within the body of the novel.

Dostoevski never tires of filling pages and pages with the unending conversations of his personages. Thanks to this abundant flow of words the imaginary persons acquire a palpable bodily existence such as no definition could contrive.

It is extremely interesting to watch Dostoevski in his cunning ways with the reader. To a perfunctory observation, he seems to define each of his personages. When he introduces a figure he nearly always begins by briefly giving a biography of that person and thus makes us believe that we know well enough with what kind of man we are dealing. But no sooner do his people begin to act—i.e., to talk and to do things—than we feel thrown off the track. They refuse to behave according to those alleged definitions. The first conceptual image we were given of them is followed by another in which we see their immediate life, independent of the author's definition; and the two do not tally. At this point, the reader, afraid to lose sight of the personages at the crossroads of these contradictory data, sets forth

in their pursuit by trying to reconcile the discrepant facts to make a unified picture. That is, he gets busy to find a definition himself. Now this is what we are doing in our living intercourse with people. Chance leads them into the ambit of our life, and nobody bothers officially to define them to us. What we have before us is their intricate reality not their plain concept. We are never quite let into their secret, they stubbornly refuse to adjust themselves to our ideas about them. And this is what makes them independent of us and brings it home that they are an effective reality transcending our imagination. But is not then Dostoevski's "realism"—let us call it that not to complicate things—not so much a matter of the persons and events he presents as of the way the reader sees himself compelled to deal with these persons and events? Dostoevski is a "realist" not because he uses the material of life but because he uses the form of life.

In this ruse of laying false scent Dostoevski indulges to the degree of cruelty. Not only does he refuse clearly to define his figures beforehand, but as their behavior varies from stage to stage they display one facet after another and thus seem to be shaped and assembled step by step before our eyes. Instead of stylizing the characters Dostoevski is pleased to have their ambiguity appear as unmitigatedly as in real life. And the reader, proceeding by trial and error, apprehensive all the time of making a mistake, must work out as best he can the actual character of those fickle creatures.

Owing to this device, among others, Dostoevski's

books, whatever their other qualities, have the rare virtue of never appearing sham and conventional. The reader never stumbles upon theatrical props; he feels from the outset immersed in a sound and effective quasi-reality. For a novel, in contrast to other literary works, must, while it is read, not be conceived as a novel; the reader must not be conscious of curtain and stage-lights. Reading Balzac, for example, we are on every page thrown out of the dream-world of the novel because we have bumped into the novelistic scaffolding. However, the most important structural peculiarity of Dostoevski's novels is harder to explain; I will return to it later.

But let me here add that this habit of confusing instead of defining, this condensation of time and space, in brief, this sluggishness or *tempo lento* are not peculiar to Dostoevski alone. All novels that are still readable employ more or less the same methods. As a West European example we may mention all the great books of Stendhal. *Le rouge et le noir*, a biographical novel which relates a few years of a man's life, is composed in the form of three or four pictures, each proceeding within its bounds like an entire novel of the Russian master.

In the last great example of prose narrative—Proust's colossal work—this inner structure becomes even more manifest and is, in a way, carried to an extreme. So slowly does the action move that it seems more like a sequence of ecstatic stillnesses without progress or tension. Reading this "remembrance of things

{ 79 }

past" we feel convinced that the permissible measure of slowness is overstepped. Plot there is almost none; and not a whit of dramatic interest. Thus the novel is reduced to pure motionless description, and the diffuse, atmospheric character, which is in fact essential to the genre, appears here with exaggerated purity. We feel the lack of a firm and rigid support, of something like the ribs in an umbrella. Deprived of its bones, the body of the novel is converted into a cloudy, shapeless mass. That is why I have said before that action and plot may play a minor part in a modern novel, but that they cannot be entirely dispensed with. They fulfill the same function—a mechanical function, it is true—as the string of a necklace, the ribs of an umbrella, the poles of a tent.

My thesis is that in the novel the so-called dramatic interest has no aesthetic value but forms a mechanical necessity. The reason for this necessity is to be found in a general law of the human soul which deserves a brief exposition.

ACTION AND CONTEMPLATION

❲ More than ten years ago I pointed out in my book *Meditaciones del Quijote** that it is the essential task of the modern novel to describe an atmosphere while other narrative literary forms—epics, romances of chivalry, adventure stories, dime novels, serials—relate concrete

* *Meditaciones del Quijote.* Madrid: Calpe, 1913.

and clearly outlined actions. Compared with a concrete action, which moves as fast as possible toward a conclusion, atmosphere signifies something diffuse and at rest. Action carries us away in its dramatic course; atmosphere invites to contemplation. In painting, a landscape has an atmospheric theme in which "nothing happens"; a battle piece narrates an isolated, well-defined event. It is not by chance that the technique of *plain air*—that is, of atmosphere—was invented in connection with landscape painting.

As time passes, my first impression has been confirmed. The taste of the best readers and the intent of the best writers have made it increasingly clear that the novel is destined to be a diffuse genre, and the latest creation of high art in the field of narrative prose, Proust's work, has given a decisive proof by overstressing the nondramatic character of the novel. Proust radically foregoes carrying the reader away through the dynamism of an intrigue and leaves him in a purely contemplative attitude. But it is this radicalism that is to blame for the difficulties and disappointments we experience in reading Proust. At the foot of each page we would implore the author to let us have a little dramatic interest, well though we know that not this but what he gives us so abundantly is the truly delicious fare. What he gives us is a microscopic analysis of human souls. With a pinch of drama—really, we should have been satisfied with almost nothing—the work would have been perfect.

How is this to be explained? Why do we find it diffi-

cult to read a novel which we appreciate unless we are accorded a minimum of action which we do not appreciate? I feel certain that anyone who gives some thought to the pleasure he derives from reading the great novels of literature will come upon this same puzzle.

That something is indispensable for something else does not imply that it is in itself estimable. To reveal a crime an informer may be needed, but that does not exonerate the informer.

Enjoyment of art is something that occurs in the mind when one sees a painting or reads a book. In order that this pleasure may be produced the psychic mechanism must function in a certain way, and all the prerequisites for this functioning must be present in the work of art although they may possess no aesthetic value or only a reflected and secondary one. In a novel, I would say, dramatic interest is a psychological necessity—not more, but not less either. But this is not the accepted belief. A suggestive plot is generally regarded as one of the decisive aesthetic factors of which there cannot be too much in a novel. Whereas I believe that action, as it is a merely mechanical element and aesthetically dead weight, ought to be reduced to a minimum. But at the same time, and with a view to Proust, I should consider this minimum indispensable.

The question transcends the range of the novel and even that of art in general and acquires major importance in philosophy. It deals with nothing less than the antagonism between action and contemplation. Two types of men become discernible: one inclined to pure

contemplation, the other eager to act, to have a hand in things, to be involved emotionally. What things are can be ascertained by contemplation only. Interest beclouds contemplation; it induces us to take sides and blinds us to certain things while throwing others into undue relief. Science, resolved to do nothing but faithfully reflect the multiform face of the cosmos, adopts, from the outset, a contemplative attitude. Similarly, art is an enjoyment of contemplation.

Contemplation and interest thus appear to be two polar forms of consciousness which in principle exclude one another. A man of action is likely to be a poor thinker, if a thinker at all, while the ideal of the sage, the stoic for instance, is to live detached and to keep his soul motionless like a still lake which impassively mirrors the fleeting skies.

But such a radical contrast is, like all radicalism, a construction of the geometrical spirit. Pure contemplation does not exist and cannot exist. When we stand before the universe unmoved by any personal interest we see nothing well. For the things equally worth seeing are innumerable. No reason speaks for our focusing on one point in preference to another, and our eyes wander aimlessly over an amorphous landscape without order or perspective. It is a humble and hackneyed truth that in order to see one must look and in order to look one must pay attention. Attention is a preference subjectively bestowed upon some things at the cost of others. I cannot focus on the first without losing sight of the second. Attention is like a ray of light which

illuminates a zone of objects and creates a penumbra around it.

Pure contemplation claims to be rigorously impartial. The spectacle of the world is taken in without any intervention and distortion on the part of the subject. But at the back of contemplation, as an indispensable presupposition, we now discern functioning the mechanism of attention which directs the eye from within the subject and throws things into perspective according to a value pattern originating in the inner recesses of the person. It is not that attention is given to what is seen but, on the contrary, only what attracts attention is seen well. Attention is a psychological a priori that operates by means of affective preferences, i.e., interests.

Modern psychology has found itself compelled paradoxically to reverse the traditional order of mental faculties. Scholasticism taught: *ignoti nulla cupido*—what is unknown is not desired. The truth is rather the opposite: Only that which has been in some way desired or, to be exact, which has previously aroused interest, is known well. How it is possible to be interested in what is not yet known presents a problem I have tried to solve in my essay "Iniciación en la estimativa."*

I cannot now enter upon a subject of such scope. Let everybody look in his own past for the circumstances under which he learned most about the world, and he will find that it was not when he deliberately set himself to seeing and nothing but seeing. It is not the countryside we visited as sightseers that we know best. Tourists,

* Cf. *Revista de Occidente*, No. IV.

although exclusively preoccupied with observing and thus in a position to carry home the richest booty of knowledge, are known to gather superficial information; their contact with a city or a country is not intimate enough to reveal the peculiar conditions. Peasants, on the other hand, whose relation to the land is one of pure interest, are apt to betray, as anyone who has traveled in rural districts will know, an amazing ignorance of their own country. Of all that surrounds them they know only such things as bear directly on their agricultural concerns.

This indicates that the most favorable position for gathering knowledge—that is, for absorbing the largest number and the best quality of objective data—lies somewhere in between pure contemplation and pressing interest. Some vital interests that are not too narrow and oppressive are required for organizing our contemplation; they must limit and articulate it by imposing upon it a perspective of attention. With respect to the countryside the hunter that hunts for sport may, *coeteris paribus*, be said to know a region best and to come into most profitable touch with all the manifold sides of the terrain. As to cities, we have seen none so well as those in which we lived in love. Love, in gathering all our soul around its delightful object, endowed us with a keener sensibility that took in the environment without making it the deliberate center of vision.

The paintings that have impressed us most are not those of museums we visited "to look at pictures" but may be humble pieces beheld in the twilight of a room

where life led us on very different purposes. In a concert a piece of music falls flat that, when a blind man plays it in the street, may move our heart.

It is evident that man's destiny is not primarily contemplative; hence the best condition for contemplation cannot be to make it a directly intended, primary act. Only when it is confined to a secondary part, while the soul is moved by the dynamism of an interest, does our perceiving and absorbing power reach a maximum.

If this were not so, the first man who looked at the universe would have beheld it in its entirety. But as it happens, mankind is discovering the world bit by bit in ever-widening circles—as though each of the vital human situations, each urge, need, and interest had served as a perceptive organ with which to explore a small neighborhood.

Hence it appears that those elements which seem to disturb pure contemplation—interests, sentiments, compulsions, affective preferences—are precisely its indispensable instruments. Any human destiny that does not labor under an unbearable strain can become a tower of contemplation—an observatory—of such scope that none, not even a seemingly more privileged one, can replace it. Thus the humblest and most wretched life is capable of receiving a theoretical sanctification and an untransferable mission of wisdom—although only certain types of existence are possessed of the optimum conditions required for attaining to the highest grades of knowledge.

But enough of generalities. Let us merely keep in

mind that there has to be at least a dash of action to make contemplation possible. Since the world of the novel is imaginary the author must mobilize in us some imaginary interest, a bit of excitement that gives our faculty of perceiving a certain guidance and a dynamic support. The reader's thirst for dramatic action has subsided with the sharpening of his psychological insight; and this is fortunate, for present-day novelists are at a loss to invent great new plots. As I see it, they need not be upset. A bit of movement and tension will do. But this bit is indispensable. Proust has demonstrated the necessity of movement by writing a paralytic novel.

THE NOVEL AS "PROVINCIAL LIFE"

⟨ Hence the order must be inverted: the action or plot is not the substance of a novel but its scaffolding, its mechanical prop. The essence of the novel—that is to say, of the modern novel with which alone I am here concerned—does not lie in "what happens" but precisely in the opposite: in the personages' pure living, in their being and being thus, above all, in the ensuing milieu. Indirect proof of this may be found in the fact that of the best novels we are liable to remember not the events, not what befalls the personages but only the personages themselves. The titles of certain books are like names of cities in which we used to live for a time. They at once bring back a climate, a peculiar smell of streets, a general type of people and a specific rhythm of life.

Only then, if at all, some particular scene may come to mind.

Indeed, novelists need not strain to build up an action. Any one serves the purpose. As a classical example of how independent a novel is of the plot I have always regarded a work of Stendhal's which he left less than half finished and which has been published under different titles: *Lucien Leuwen, Le chasseur vert*, etc. The existing part amounts to a considerable number of pages. Yet nothing happens in it. A young officer comes to the capital of a *départment* and falls in love with a lady who belongs to the provincial aristocracy. We witness in minute detail the development of this delightful sentiment in the two persons: that is all. When the action begins to become involved, the fragment ends. But it leaves us with the impression that we could have gone on forever reading page after page about life in that corner of France, about the lady of the legitimist party and the young soldier in his amaranthine uniform.

And what else is needed? Above all, let us pause to think what this "else" could be—those "interesting things," those marvelous experiences. In the realm of the novel nothing of the kind exists (we do not now speak of serials or of scientific adventure stories in the manner of Poe, Wells, etc.); here life is precisely daily life. It is in reporting the wonders of the simple, unhaloed hour, not in expatiating on the extraordinary, that the novel displays its specific graces.* Not by wid-

* This aesthetic stress on the daily and this strict preclusion of marvels and wonders is essential to the modern novel. It charac-

ening our horizon with tales of unheard-of adventures can the novelist expect to captivate us. The opposite procedure is required: the reader's horizon must be narrowed. Let me explain.

If by horizon we understand the circle of people and events that integrate the world of each of us, we may be misled into believing that certain horizons are so wide and varied that they are particularly interesting while others are too narrow and monotonous to command interest. In point of fact, the duchess whose world seems so dramatic to a young secretary is liable to be quite as bored in her glamorous sphere as the romantic typist in her drab and obscure environment. Being a duchess is as daily a form of life as any other.

The truth is that no horizon is especially interesting by itself, by virtue of its peculiar content, and that any horizon, wide or narrow, brilliant or dull, varied or monotonous, may possess an interest of its own which merely requires a vital adjustment to be discovered. Human vitality is so exuberant that in the sorriest desert it still finds a pretext for glowing and trembling. Living in the city we cannot understand how it is possible to exist in the village. But no sooner has some chance landed us there than we find ourselves vehemently taking sides in the local gossip.

In my judgment, this is of paramount importance to

terizes *Don Quixote* in contrast to the romances of chivalry. Indeed, were we to determine the conditions of the modern novel, we should only need to ascertain what a literary prose production must look like that makes a principle of eliminating marvels.

the novel. The author must see to it that the reader is cut off from his real horizon and imprisoned in a small, hermetically sealed universe—the inner realm of the novel. He must make a "villager" of him and interest him in the inhabitants of this realm. For, however admirable these may be, they cannot hold their own against the beings of flesh and bone who form the reader's daily surroundings and constantly claim his interest. To turn each reader into a temporal "provincial" is the great secret of the novelist. Instead of widening the horizon—what novelistic horizon could be wider and richer than the humblest real one?—he must contract and limit it. Thus and only thus can he make the reader care about what is going on inside the novel.

No horizon, I repeat, is interesting for its content. Any one of them is interesting through its *form*—its form as a horizon, that is, as a cosmos or complete world. Microcosm and macrocosm are equally cosmos; they differ only in the size of their radii; but for a being that lives inside, each has a constant absolute size. We are reminded of Poincaré's remark—which foreshadows the theory of relativity—that, if everything in our world contracted and shrank in the same proportion, we should not notice the difference.

The interdependence between horizon and interest—that each horizon has its interest—is the vital law thanks to which in the aesthetic field the novel is possible.

From this law derive a few norms of the genre.

IMPERVIOUSNESS

⟦ Let us observe ourselves the moment we have finished reading a great novel. Is it not as though we were emerging from another world where we were held incommunicado? That there can have been no communication is clear; for we are aware of no transition. A second ago we were in Parma with Count Mosca and La Sanseverina, with Clélia and Fabrice; we lived their lives with them, immersed in their atmosphere, their time and place. Now, abruptly, we find ourselves in our room, our city, our time; and already our accustomed preoccupations begin to stir. There is an interval of indecision and suspense. Perchance a sudden wave of recollection washes us back into the universe of the novel, and with a certain effort, as though struggling through a liquid element, we must regain the shores of our existence proper. Were someone to find us in just that moment, our dilated pupils would betray our shipwrecked condition.

Novel I call the literary prose work that produces this effect. And a novel that lacks this glorious and unique magic is a poor novel whatever other virtues it may possess. Sublime and beneficent the power of this sovereign modern art that multiplies our existence, freeing us from our own self and generously bestowing upon us the gift of transmigration!

To achieve this, the author must begin by luring us into the closed precinct that is his novel and then keep us there cut off from any possible retreat to the real

space we left behind. The first is easy; almost any promise finds us ready to enter through the gate the novelist holds open for us. The second is more difficult. The author must build around us a wall without chinks or loopholes through which we might catch, from within the novel, a glimpse of the outside world. For were we allowed to compare the inner world of the book with outer reality and invited to "live," the conflicts, problems, and emotions the book has to offer would seem so small and futile that all their significance would be lost. It would be like looking in a garden at a picture representing a garden. The painted garden blooms only inside a house against the neutral background of a wall where it is like a window opening into an imaginary noonday world.

In my judgment, no writer can be called a novelist unless he possesses the gift of forgetting, and thereby making us forget, the reality beyond the walls of his novel. Let him be as realistic as can be; that is to say, let the microcosm of his novel consist of unquestionably true-to-life elements—he will have lost out if he cannot keep us from remembering that there exists an extramural world.

Hence every novel is still-born that is laden with transcendental intentions, be they political, ideological, symbolical, or satirical. For those themes are of such a nature that they cannot be dealt with fictitiously, they have meaning only in relation to the actual horizon of each individual. As soon as they are broached we feel expelled from the imaginary sphere of the novel and

compelled to establish contact with the absolute realm on which our real existence depends. How can we care about the imaginary destinies of his personages when the author forces us to face the acute problem of our own political or metaphysical destiny? No, he must by all means render us insensible to reality and keep up the hypnosis in which we lead an imaginary life.

This seems to me the cause of the enormous difficulty—if not impossibility—of writing a good historical novel. The aspiration that the imagined cosmos shall at the same time be historically correct leads to a perpetual clash between two different horizons. And since each horizon calls for a special adjustment of our perceptive apparatus we must constantly change our attitude. No opportunity is given us of either quietly dreaming the novel or clearly thinking the historical facts. Again and again we pause, uncertain whether to hold the events and characters against the imaginary or the historical horizon, and this ambivalence imparts a false and uncomfortable complexion to everything. Any attempt to merge the two worlds only leads to their mutual annihilation. The author, we feel, falsifies the historical facts by bringing them too near to us and weakens the novel by removing it too far away from us toward the abstract plane of historical truth.

Imperviousness is but the special form taken on in the novel by the generic imperative of art: to be without transcending consequence. This self-sufficiency of art cannot but irritate all muddleheads. But what are we to do about it, since after an inexorable law every-

thing must be what it is and renounce being something else? There are people who want to be everything. Not content with being artists they want to be politicians and lead the multitude, or to be prophets entrusted with administering the will of God and guiding the consciences of men. But the arts take their revenge on any artist who wants to be more than an artist by letting his work fail even artistically. Conversely, a poet's politics rarely attain to more than an ingenuous, inept gesture.

By virtue of a purely aesthetic necessity the novel must be impervious, it must possess the power of forming a precinct, hermetically closed to all actual reality. From this condition there follows, among many other consequences, that the novel cannot propagate philosophical, political, sociological, or moral ideas; it can be nothing beyond a novel. As little can its inside transcend into any outside as a sleeper's arm can reach out into the waking world to catch a real object and introduce it into the magic sphere of his dream. The sleeper's arm is a phantom, too limp to lift a petal. So incompatible are the two worlds that their slightest contact abolishes one of them. As children we never could stick a finger through the shimmering skin of the soap bubbles; always those frail, floating globes would vanish in a sudden explosion, leaving a tear of foam on the flags.

This does by no means preclude that a novel, once it has been "lived" in a delightful sleep-walking way, may afterwards evoke in us all sorts of vital repercussions. The symbolical meaning of *Don Quixote* is not

contained within the novel, we construct it from without when musing over our impressions of the book. Dostoevski's religious and political ideas are not operative agencies within the body of his work; they appear there with the same fictitious character as the faces and the frenetic passions of the figures.

Let all novelists look at the doors of the Florentine baptistery wrought by Lorenzo Ghiberti! In a series of small squares they show the whole Creation: men, women, animals, fruits, buildings. The sculptor was concerned with nothing but to model all those forms one after another. We still seem to feel the trembling delight with which the hand set down the arched brow of the ram Abraham espied in the thicket, and the plump form of the apple, and the foreshortened edifice. Similarly, a novelist must be inspired above all by a wonderful enthusiasm to tell a tale and to invent men and women and conversations and passions. A silkworm enclosed in his magic cocoon, he must forget the world he leaves behind and happily go about polishing the walls of his self-made prison so as to stop up all pores against the air and light of reality.

In simpler words, a novelist while he writes his novel must care more about his imaginary world than about any other possible world. If he does not care, how can he make us care? Somnambulist himself, he must infect us with his divine somnambulism.

THE NOVEL A DENSE FORM

⟨ What I have called the impervious or hermetic character of the novel will be further elucidated by a comparison between the novel and the lyrical poem. We admire a poem when we see it rising miraculously from reality, as the artificial jet of a fountain rises from the surrounding scenery. Poems are made to be looked at from without—the same as statues, the same as Greek temples. They do not interfere with our daily world, or rather, they derive their peculiar grace from establishing amid our reality their naked unreality with Olympian innocence. Whereas the novel is destined to be perceived from within itself—the same as the real world in which, by inexorable metaphysical order, each man forms, in each moment of his life, the center of his own universe. To enjoy a novel we must feel surrounded by it on all sides; it cannot exist as a more or less conspicuous thing among the rest of things. Precisely because it is a preeminently realistic genre it is incompatible with outer reality. In order to establish its own inner world it must dislodge and abolish the surrounding one.

From this imperative derive all the other conditions of the novelistic form that we have pointed out. They all fall under the heading of imperviousness. Thus the imperative of autopsy follows inevitably from the fact that the novelist finds himself compelled to cover the real world with his imaginary world. If we are not to see a thing, if a thing is to be concealed, we must be shown other things that conceal it. But shades are known to

cast no shadow and not to screen from sight what is be-
hind them—by these two tokens the dead in purgatory
recognize Dante as a trespasser from the land of the
living. Instead of defining his figures and their senti-
ments, the novelist must therefore evoke them in order
that their self-presence may intercept our vision of the
real world about us.

Now, as far as I can see, there is no other way of
achieving this but by supplying a wealth of detail. The
reader must be caught in a dense web of innumerable
minutely told circumstances. What is our life but an
immense agglomeration of trifles?

Since exaggeration always serves to call our attention
to the thing in its rightful measure, Proust's work, by
overdoing the prolixity and minuteness, has helped us
to recognize that great novels are essentially lavish of
particulars. Indeed, the books of Cervantes, Stendhal,
Dickens, Dostoevski are of the tightly packed sort. All
the time we are getting more facts than we can possibly
keep in mind, and yet we are left with the impression
that beyond those explicitly mentioned others are pres-
ent potentially, as it were. Great novels are atolls built
by myriads of tiny animals whose seeming frailness
checks the impact of the seas.

For this reason a novelist should never attack a sub-
ject unless he knows it thoroughly. He must produce *ex
abundantia.* Where he finds himself moving in shallow
waters he will never make good.

Things must be accepted as they are. The novel is
not a lithe, agile, winged form. It is not for nothing that

all the great novels that we now like best are a bit heavy. The poet may set forth, a wandering minstrel, with his lyre under his arm, but the novelist moves with cumbrous baggage like circuses or nomadic tribes. He carries the furnishings of a whole world on his back.

DECLINE AND PERFECTION

(The conditions so far mentioned merely define the level at which the novel begins; they mark the water-line, as it were, of its continent. In the following we shall be concerned with conditions that determine the higher or lower altitude of a work.

The stuff novels are made of may vary a good deal. It may consist in trite and hackneyed observations, such as an average man uses for the purpose of his existence; or it may contain experiences for which one must probe deep into the secrets of the soul. The quality of the detail is among the factors that decide the rank of a book. The great novelist, contemptuous of the surface features of his personages, dives down into their souls and returns, clutching in his hand the deep-sea pearl. But precisely for this reason the average reader does not understand him.

In the beginnings of the novel the difference between good novels and poor novels was not so great. As nothing had yet been said they all had to begin with saying the obvious. Today, in the great hour of the decline of the genre, good novels and poor ones differ very much

indeed. Hence the opportunity of achieving the perfect work is excellent—though extremely precarious. For it would be rash to assume that the season of decline is unfavorable in every respect. Rather, the works of highest rank are likely to be products of the last hour when accumulated experience has utterly refined the artistic sensitivity. The decline of an artistic genre, like that of a race, affects but the average specimens.

This is one of the reasons why I believe—utterly pessimistic though I feel about the immediate future of the plastic arts and of politics, though not of science or of philosophy—that the novel is one of the few fields that may still yield illustrious fruits, more exquisite ones perhaps than were ever garnered in previous harvests. As a routine production, as an exploitable mine, the novel may be finished. The large veins, accessible to any diligent hand, are worked out. What remains are hidden deposits and perilous ventures into the depths where, perchance, the most precious crystals grow. But that is work for minds of rare distinction.

The last perfection, almost always the fruit of the last hour, has not yet been attained by the novel. Neither its form or structure nor its material has passed through the last crucibles. Regarding the material I find some reason for optimism in the following consideration.

The material proper of the novel is imaginary psychology. Imaginary psychology advances in unison with scientific psychology and psychological intuition which is used in daily life. Now, few things have progressed

so much in Europe these last fifty years as the knowledge of the human soul. For the first time in history there exists a science of psychology, in its beginnings only, it is true, but even so without equal in former ages. Add to this a refined ability of divining our neighbor and analyzing our own inner life. All this psychological knowledge accumulated in the contemporary mind through research or through spontaneous experience is to no small degree responsible for the present failure of the novel. Authors that yesterday seemed excellent appear naïve today because the present reader is a much better psychologist than the old author. (Who knows whether the political confusion in Europe, which to my mind is much more alarming and deep-seated than is now apparent, does not spring from the same causes? Who knows whether States of the modern type are not possible only while the citizens live in a state of psychological dumbness?)

A related phenomenon is the dissatisfaction we feel when reading the classical historians. The psychology they use seems inadequate and vague and far from satisfying our apparently subtler taste.*

Novelists and historians will hardly fail to make use of this progress of psychology. Humanity has always satisfied its desires if they were clear and concrete. Thus it is fairly safe to predict that—apart from philosophy—history and the novel will furnish the strongest intellectual emotions the near future holds in reserve for us.

* Cf. for this point the author's essay "Las Atlántidas" in his collected works: *Obras* (Espasa Calpe, 1932), II, 821.

⟮ These notes on the novel have so resolutely an air of being interminable that it becomes necessary to cut them short. One more step would prove fatal. So far they have moved on a plane of ample generality, avoiding entanglements in casuistry. But in aesthetics, the same as in ethics, the general principles form but a system of reference set down with a view to the concrete analysis of special cases. It is with this analysis that the most appealing part of the investigation commences; but with it we also venture into a field without bounds. Thus prudence suggests that I stop here. —I would, however, add one last remark.

The material of the novel, we were saying, is, above all, imaginary psychology. It is not easy to explain in a few words what this means. The current belief is that psychological phenomena, like the phenomena of experimental physics, obey factual laws. If this is so, all the novelist can do is to observe and to copy the real processes in existing souls. But he cannot invent psychological processes and construct souls as the mathematician constructs geometrical figures. Yet the enjoyment of novels presupposes exactly this.

When a novelist expounds a psychological process he does not expect us to accept it as something that has actually happened—who would guarantee its reality? —but he trusts that it possesses an inner evidence, an evidence akin to that which makes mathematics possible. And let it not be said that the psychological development he describes seems convincing when it coincides

with cases we have witnessed in life. An awkward thing it would be if the novelist had to rely on the chance experiences of this or that reader of his. Rather we recall that one of the peculiar attractions Dostoevski's work used to hold for us lay in the unfamiliar behavior of his personages. Small chance there is indeed that a reader in Sevilla should ever in his life have met people as chaotic and turbulent as the Karamasoffs. And yet, dull though he may be, the psychic mechanism of those souls seems to him as cogent and evident as the steps of a mathematical proof which uses dimensions never seen by human eyes.

There exists in psychology, just as in mathematics, an evidence a priori. Because of this in either field imaginary construction is possible. Where only facts are subject to laws but no laws obtain that regulate the imagination it is impossible to construct. Any attempt to do so can be no more than an arbitrary caprice.

Because this is not recognized the psychology in a novel is taken to be identical with that of real life, and it is assumed that the author can do nothing but copy reality. So coarse a reasoning lies at the bottom of what is currently called "realism." I cannot now discuss this involved term which I have been careful always to use in quotation marks to render it suspect. Its incongruity will clearly transpire when we observe that it does not even apply to the very works from which it allegedly derives. The personages of those works are almost all of them so different from those we meet in our own environment that, even supposing they were copied from

existing persons, we should not recognize them as such. People in a novel need not be like real ones, it is enough that they are possible. And this psychology of possible human minds, which I have called imaginary psychology, is the only one that matters to the novel. That a novel may, apart from this, be concerned with giving a psychological interpretation of actual social types and environments can provide an additional piquancy, but it is not essential. (One of the points I am leaving untouched is that the novel lends itself more easily than any other literary form to absorbing elements alien to art. *Within* the novel almost anything fits: science, religion, sociology, aesthetic criticism—if only it is ultimately derealized and confined within the inner world of the novel; i.e., if it remains without actual and effective validity. In other words, a novel can contain as much sociology as it desires, but the novel itself cannot be sociological. The dose of alien elements a book can bear, lastly, depends on the author's capability of dissolving them in the atmosphere of the novel as such. But this subject obviously belongs to casuistry, and I drop it terrified.)

This possibility of constructing human souls is perhaps the major asset of future novels. Everything points in this direction. The interest in the outer mechanism of the plot is today reduced to a minimum. All the better: the novel must now revolve about the superior interest emanating from the inner mechanism of the personages. Not in the invention of plots but in the invention of interesting characters lies the best hope of the novel. *Translated from the Spanish by Helene Weyl*

ON POINT OF VIEW
IN THE ARTS

❨ When history is what it should be, it is an elaboration of cinema. It is not content to install itself in the successive facts and to view the moral landscape that may be perceived from here; but for this series of static images, each enclosed within itself, history substitutes the image of a movement. "Vistas" which had been discontinuous appear to emerge one from another, each prolonging the other without interruption. Reality, which for one moment seemed an infinity of crystallized facts, frozen in position, liquifies, springs forth, and flows. The true historical reality is not the datum, the fact, the thing, but the evolution formed when these materials melt and fluidify. History moves; the still waters are made swift.

I I

In the museum we find the lacquered corpse of an evolution. Here is the flux of that pictorial anxiety which has budded forth from man century after century. To conserve this evolution, it has had to be undone, broken up, converted into fragments again and congealed as in a refrigerator. Each picture is a crystal with unmistakable and rigid edges, separated from the others, a hermetic island.

And, nonetheless, it is a corpse we could easily revive. We would need only to arrange the pictures in a certain order and then move the eye—or the mind's eye—quickly from one to the other. Then, it would become clear that the evolution of painting from Giotto

to our own time is a unique and simple action with a beginning and an end. It is surprising that so elementary a law has guided the variations of pictorial art in our western world. Even more curious, and most disturbing, is the analogy of this law with that which has directed the course of European philosophy. This parallel between the two most widely separated disciplines of culture permits us to suspect the existence of an even more general principle which has been active in the entire evolution of the European mind. I am not, however, going to prolong our adventure to this remote arcanum, and will content myself, for the present, with interpreting the visage of six centuries that has been Occidental painting.

III

Movement implies a mover. In the evolution of painting, what is it that moves? Each canvas is an instant in which the mover stands fixed. What is this? Do not look for something very complicated. The thing that varies, the thing that shifts in painting, and which by its shifts produces the diversity of aspects and styles, is simply the painter's point of view.

It is natural enough. An abstract idea is ubiquitous. The isosceles triangle presents the same aspect on Earth as on Sirius. On the other hand, a sensuous image bears the indelible mark of its localization, that is, the image presents something seen from a definite point of view.

This localization of the sensible may be strict or vague, but it is inevitable. A church spire, a sail at sea, present themselves to us at a distance that for practical purposes we may estimate with some accuracy. The moon or the blue face of heaven are at a distance essentially imprecise, but quite characteristic in their imprecision. We cannot say that they are so many miles away; their localization in distance is vague, but this vagueness is not indetermination.

Nonetheless, it is not the geodetic *quantity* of distance which decisively influences the painter's point of view, but its optical *quality*. "Near" and "far" are relative, metrically, while to the eye they may have a kind of absolute value. Indeed, the *proximate vision* and the *distant vision* of which physiology speaks are not notions that depend chiefly on measurable factors, but are rather two distinct ways of seeing.

If we take up an object, an earthen jar, for example, and bring it near enough to the eyes, these converge on it. Then, the field of vision assumes a peculiar structure. In the center there is the favored object, fixed by our gaze; its form seems clear, perfectly defined in all its details. Around the object, as far as the limits of the field of vision, there is a zone we do not look at, but which, nevertheless, we see with an indirect, vague, inattentive vision. Everything within this zone seems to be situated behind the object; this is why we call it the "background." But, moreover, this whole background is blurred, hardly identifiable, without accented

form, reduced to confused masses of color. If it is not something to which we are accustomed, we cannot say what it is, exactly, that we see in this indirect vision.

The proximate vision, then, organizes the whole field of vision, imposing upon it an optical hierarchy: a privileged central nucleus articulates itself against the surrounding area. The central object is a luminous hero, a protagonist standing out against a "mass," a visual *plebs*, and surrounded by a cosmic chorus.

Compare this with distant vision. Instead of fixing a proximate object, let the eye, passive but free, prolong its line of vision to the limit of the visual field. What do we find then? The structure of our hierarchized elements disappears. The ocular field is homogeneous; we do not see one thing clearly and the rest confusedly, for all are submerged in an optical democracy. Nothing possesses a sharp profile; everything is background, confused, almost formless. On the other hand, the duality of proximate vision is succeeded by a perfect unity of the whole visual field.

I V

To these different modes of seeing, we must add another more important one.

In looking close-up at our earthen jar, the eye-beam strikes the most prominent part of its bulge. Then, as if shattered at this point of contact, the beam is splintered into multiple lines which glide around the sides

of the vase and seem to embrace it, to take possession of it, to emphasize its rotundity. Thus the object seen at close range acquires the indefinable corporeality and solidity of filled volume. We see it "in bulk," convexly. But this same object placed farther away, for distant vision, loses this corporeality, this solidity and plentitude. Now it is no longer a compact mass, clearly rotund, with its protuberance and curving flanks; it has lost "bulk," and become, rather, an insubstantial surface, an unbodied spectre composed only of light.

Proximate vision has a tactile quality. What mysterious resonance of touch is preserved by sight when it converges on a nearby object? We shall not now attempt to violate this mystery. It is enough that we recognize this quasi-tactile density possessed by the ocular ray, and which permits it, in effect, to embrace, to touch the earthen jar. As the object is withdrawn, sight loses its tactile power and gradually becomes pure vision. In the same way, things, as they recede, cease to be filled volumes, hard and compact, and become mere chromatic entities, without resistance, mass or convexity. An age-old habit, founded in vital necessity, causes men to consider as "things," in the strict sense, only such objects solid enough to offer resistance to their hands. The rest is more or less illusion. So in passing from proximate to distant vision an object becomes illusory. When the distance is great, there on the confines of a remote horizon—a tree, a castle, a mountain range—all acquire the half-unreal aspect of ghostly apparitions.

V

A final and decisive observation.

When we oppose proximate to distant vision, we do not mean that in the latter the object is farther away. To look means here, speaking narrowly, to focus both ocular rays on a point which, thanks to this, becomes favored, optically privileged. In distant vision we do not fix the gaze on any point, but rather attempt to embrace the whole field, including its boundaries. For this reason, we avoid focusing the eyes as much as possible. And then we are surprised to find that the object just perceived—our entire visual field—is concave. If we are in a house the concavity is bordered by the walls, the roof, the floor. This border or limit is a surface that tends to take the form of a hemisphere viewed from within. But where does the concavity begin? There is no possibility of doubt: it begins at our eyes themselves.

The result is that what we see at a distance is hollow space as such. The content of perception is not strictly the surface in which the hollow space terminates, but rather the whole hollow space itself, from the eyeball to the wall or the horizon.

This fact obliges us to recognize the following paradox: the object of sight is not farther off in distant than in proximate vision, but on the contrary is nearer, since it begins at our cornea. In pure distant vision, our attention, instead of being directed farther away, has drawn back to the absolutely proximate, and the eye-

beam, instead of striking the convexity of a solid body and staying fixed on it, penetrates a concave object, glides into a hollow.

V I

Throughout the history of the arts in Europe, then, the painter's point of view has been changing from proximate to distant vision, and painting, correspondingly, which begins with Giotto as painting of bulk, turns into painting of hollow space.

This means there has been nothing capricious in the itinerary followed by the painter's shift of attention. First it is fixed upon the body or volume of an object, then upon what lies between the body of the object and the eye, that is, the hollow space. And since the latter is in front of the object, it follows that the journey of the pictorial gaze is a retrogression from the distant—although close by—toward what is contiguous to the eye.

According to this, the evolution of Western painting would consist in a retraction from the object toward the subject, the painter.

The reader may test for himself this law that governs the movement of pictorial art by a chronological review of the history of painting. In what follows, I limit myself to a few examples that are, as it were, stages on such a journey.

The Flemish and the Italians cultivate with passion the painting of bulk. One would say they paint with their hands. Every object appears unequivocally solid, corporeal, tangible. Covering it is a polished skin, without pores or growth, which seems to delight in asserting its own rounded volume. Objects in the background receive the same treatment as those of the foreground. The artist contents himself with representing the distant as smaller than the proximate, but he paints both in the same way. The distinction of planes is, then, merely abstract, and is obtained by pure geometrical perspective. Pictorially, everything in these pictures is in one plane, that is, everything is painted from close-up. The smallest figure, there in the distance, is as complete, spherical and detached as the most important. The painter seems to have gone to the distant spot where they are, and from near at hand to have painted them as distant.

But it is impossible to see several objects close-up at the same time. The proximate gaze must shift from one to the other to make each in turn the center of vision. This means that the point of view in a primitive picture is not single, but as many points of view as there are objects represented. The canvas is not painted as a unity, but as a plurality. No part is related to any other; each is perfect and separate. Hence the best means of distinguishing the two tendencies in pictorial art—painting of bulk and painting of hollow space—is to take a

portion of the picture and see whether, in isolation, it is enough to represent something fully. On a canvas of Velásquez, each section contains only vague and monstrous forms.

The primitive canvas is, in a certain sense, the sum of many small pictures, each one independent and each painted from the proximate view. The painter has directed an exclusive and analytic gaze at each one of the objects. This accounts for the diverting richness of these Quattrocento catalogues. We never have done with looking at them. We always discover a new little interior picture that we had not observed closely enough. On the other hand, they cannot be seen as a whole. The pupil of our eye has to travel step by step along the canvas, pausing in the same point of view that the painter successively took.

VIII RENAISSANCE

Proximate vision is exclusive, since it apprehends each object in itself and separates it from the rest. Raphael does not modify this point of view, but introduces in the picture an abstract element that affords it a certain unity; this is composition, or architecture. He continues to paint one object after another, like a primitive; his visual apparatus functions on the same principle. But instead of limiting himself, like the primitive, to paint what he sees as he sees it, he submits everything to an external force: the geometrical idea of unity. Upon the

analytic form of objects, there is imperatively fixed the synthetic form of composition, which is not the visible form of an object, but a pure rational schema. (Leonardo, too, for example in his triangular canvases).

Raphael's pictures, then, do not derive from, and cannot be viewed in, a unified field of vision. But there is already in them the rational basis of unification.

IX TRANSITION

If we pass from the primitive and the Renaissance toward Velásquez, we find in the Venetians, but especially in Tintoretto and El Greco, an intermediate stage. How shall we define it?

In Tintoretto and El Greco two epochs meet. Hence the anxiety, the restlessness that marks the work of both. These are the last representatives of painting in bulk, and they already sense the future problems of painting in hollow space without, however, coming to grips with them.

Venetian art, from the beginning, tends to a distant view of things. In Giorgione and Titian, the bodies seem to wish to lose their hard contours, and float like clouds or some diaphanous fabric. However, the will to abandon the proximate and analytic point of view is still lacking. For a century, there is a struggle between both principles, with victory for neither. Tintoretto is an extreme example of this inner tension, in which distant vision is already on the point of victory. In the canvases

of the Escorial he constructs great empty spaces. But in this undertaking he is forced to lean on architectonic perspective as on a crutch. Without those columns and cornices that flee into the background, Tintoretto's brush would fall into the abyss of that hollow space he aspired to create.

El Greco represents something of a regression. I believe that his modernity and his nearness to Velásquez has been exaggerated. El Greco is still chiefly preoccupied with volume. The proof is that he may be accounted the last great foreshortener. He does not seek empty space; in him there remains the intention to capture the corporeal, filled volume. While Velásquez, in *The Ladies in Waiting* and *The Spinners*, groups his human figures at the right and left, leaving the central space more or less free—as if space were the true protagonist—El Greco piles up solid masses over the whole canvas that completely displace the air. His works are usually stuffed with flesh.

However, pictures like *The Resurrection, The Crucified* (Prado) and *Pentecost*, pose the problems of painting in depth with rare power.

But it is a mistake to confuse the painting of depth with that of hollow space or empty concavity. The former is only a more learned way of asserting volume. On the other hand, the latter is a total inversion of pictorial intention.

What we find in El Greco is that the architectonic principle has completely taken over the represented

objects and forced these, with unparalleled violence, to submit to its ideal schema. In this way, the analytic vision, which seeks volume by emphasizing each figure for its own sake, is mitigated and neutralized, as it were, by the synthetic intention. The formal dynamic schema that dominates the picture imposes on it a certain unity and fosters the illusion of a single point of view.

Furthermore, there appears already in the work of El Greco another unifying element: chiaroscuro.

X THE CHIAROSCURISTS

Raphael's composition, El Greco's dynamic schema, are postulates of unity that the artist throws upon his canvas;—but nothing more. Every object in the picture continues as before to assert its volume, and, consequently, its independence and particularism. These unities, then, are of the same abstract lineage as the geometrical perspective of the primitives. Derived from pure reason, they show themselves incapable of giving form to the materials of the picture as a whole; or, in other words, they are not pictorial principles. Each section of the picture is painted without their intervention.

Compared to them, chiaroscuro signifies a radical and more profound innovation.

When the eye of the painter seeks the body of things, the objects placed in the painted area will demand, each for itself, an exclusive and privileged point of view.

The picture will possess a feudal constitution in which every element will maintain its personal rights. But here, slipping between them, is a new object gifted with a magic power that permits it—even more—obliges it to be ubiquitous and occupy the whole canvas without having to dispossess the others. This magic object is light. It is everywhere single and unique throughout the composition. Here is a principle of unity that is not abstract but real, a thing among other things, not an idea or schema. The unity of illumination or chiaroscuro imposes a unique point of view. The painter must now see his entire work as immersed in the ample element of light.

Thus Ribera, Caravaggio, and the young Velásquez (*The Adoration of the Magi*). They still seek for corporeality according to accepted practice. But this no longer interests them primarily. The object in itself begins to be disregarded and have no other role than to serve as support and background for the light playing upon it. One studies the trajectory of light, emphasizing the fluidity of its passage over the face of volumes, over bulkiness.

Is it not clear what shift in the artist's point of view is implied by this? The Velásquez of *The Adoration of the Magi* no longer fixes his attention upon the object as such but upon its surface, where the light falls and is reflected. There has occurred, then, a retraction of vision, which has stopped being a hand and released its grasp of the rounded body. Now, the visual ray halts

at the point where the body begins and light strikes resplendently; from there it seeks another point on another object where the same intensity of illumination is vibrating. The painter has achieved a magic solidarity and unification of all the light elements in contrast to the shadow elements. Things of the most disparate form and condition now become equivalent. The individualistic primacy of objects is finished. They are no longer interesting in themselves, and begin to be only a pretext for something else.

XI VELÁSQUEZ

Thanks to chiaroscuro, the unity of the picture becomes internal, and not merely obtained by extrinsic means. However, under the light, volumes continue to lurk, the painting of bulk persists through the refulgent veil of light.

To overcome this dualism, art needed a man of disdainful genius, resolved to have no interest in bodies, to deny their pretensions to solidity, to flatten their petulant bulk. This disdainful genius was Velásquez.

The primitive, enamoured of objective shapes, seeks them arduously with his tactile gaze, touches them, embraces them. The chiaroscurist, already less taken with corporeality, lets his ray of vision travel, as along a railway track, with the light ray that migrates from one surface to the next. Velásquez, with formidable

audacity, executes the supreme gesture of disdain that calls forth a whole new painting: he halts the pupil of the eye. Nothing more. Such is this gigantic revolution.

Until then, the painter's eye had Ptolemaically revolved about each object, following a servile orbit. Velásquez despotically resolves to fix the one point of view. The entire picture will be born in a single act of vision, and things will have to contrive as best they may to move into the line of vision. It is a Copernican revolution, comparable to that promoted by Descartes, Hume and Kant in philosophic thought. The eye of the artist is established as the center of the plastic Cosmos, around which revolve the forms of objects. Rigidly, the ocular apparatus casts its ray directly forward, without deviating to one side or the other, without preference for any object. When it lights on something, it does not fix upon it, and, consequently, that something is converted, not into a round body, but into a mere surface that intercepts vision.[1]

The point of view has been retracted, has placed itself farther from the object, and we have passed from proximate to distant vision, which, strictly speaking, is the more proximate of the two kinds of vision. Between the eye and the bodies is interposed the most immediate object: hollow space, air. Floating in the air, transformed into chromatic gases, formless pennons, pure

[1] If we look at an empty sphere from without, we see a solid volume. If we enter the sphere we see about us a surface that limits the interior concavity.

reflections, things have lost their solidity and contour. The painter has thrown his head back, half-closed his eyelids, and between them has pulverized the proper form of each object, reducing it to molecules of light, to pure sparks of color. On the other hand, his picture may be viewed from a single point of view, as a whole and at a glance.

Proximate vision dissociates, analyzes, distinguishes— it is feudal. Distant vision synthesizes, combines, throws together—it is democratic. The point of view becomes synopsis. The painting of bulk has been definitively transformed into the painting of hollow space.

XII IMPRESSIONISM

It is not necessary to remark that, in Velásquez, the moderating principles of the Renaissance persisted. The innovation did not appear in all its radicalism until the Impressionists and Post-Impressionists.

The premises formulated in our first paragraphs may seem to imply that the evolution had terminated when we arrive at the painting of hollow space. The point of view, transforming itself from the multiple and proximate to the single and distant, appears to have exhausted its possible itinerary. Not at all! We shall see that it may retreat even closer to the subject. From 1870 until today, the shift of viewpoint has continued, and these latest stages, precisely because of their surprising and paradoxical character, confirm the fatal law to which I

alluded at the beginning. The artist, starting from the world about him, ends by withdrawing into himself.

I have said that the gaze of Velásquez, when it falls on an object, converts it into a surface. But, meanwhile, the visual ray has gone along its path, enjoying itself by perforating the air between the cornea and distant things. In *Ladies in Waiting* and *The Spinners*, we see the satisfaction with which the artist has accentuated hollow space as such. Velásquez looks straight to the background; thus, he encounters the enormous mass of air between it and the boundary of his eye. Now, to look at something with the central ray of the eye is what is known as direct vision or vision *in modo recto*. But behind the axial ray the pupil sends out many others at oblique angles, enabling us to see *in modo obliquo*. The impression of concavity is derived from the *modo recto*. If we eliminate this—for example, by blinking the eyes—we have only oblique vision, those side-views "from the tail of the eye" which represent the height of disdain. Thus, the third dimension disappears and the field of vision tends to convert itself entirely into surface.

This is what the successive impressionisms have done. Velásquez' background has been brought forward, and so of course ceases to be background since it cannot be compared with a foreground. Painting tends to become planimetric, like the canvas on which one paints. One arrives, then, at the elimination of all tactile and corporeal resonance. At the same time, the atomization of

things in oblique vision is such that almost nothing remains of them. Figures begin to be unrecognizable. Instead of painting objects as they are seen, one paints the experience of seeing. Instead of an object as impression, that is, a mass of sensations. Art, with this, has withdrawn completely from the world and begins to concern itself with the activity of the subject. Sensations are no longer things in any sense; they are subjective states through which and by means of which things appear.

Let us be sure we understand the extent of this change in the point of view. It would seem that in fixing upon the object nearest the cornea, the point of view is as close as possible to the subject and as far as possible from things. But no—the inexorable retreat continues. Not halting even at the cornea, the point of view crosses the last frontier and penetrates into vision itself, into the subject himself.

XIII CUBISM

Cézanne, in the midst of his impressionist tradition, discovers volume. Cubes, cylinders, cones begin to emerge on his canvases. A careless observer might have supposed that, with its evolution exhausted, pictorial art had begun all over again and that we had relapsed back to the point of view of Giotto. Not at all! In the history of art there have always been eccentric movements tending toward the archaic. Nevertheless, the

main stream flows over them and continues its inevitable course.

The cubism of Cézanne and of those who, in effect, were cubists, that is, stereometrists, is only one step more in the internalizing of painting. Sensations, the theme of impressionism, are subjective states; as such, realities, effective modifications of the subject. But still further within the subject are found the ideas. And ideas, too, are realities present in the individual, but they differ from sensations in that their content—the ideated—is unreal and sometimes even impossible. When I conceive a strictly geometrical cylinder, my *thought* is an effective act that takes place in me; but the geometric cylinder of which I think is unreal. Ideas, then, are subjective realities that contain virtual objects, a whole specific world of a new sort, distinct from the world revealed by the eye, and which emerges miraculously from the psychic depths.

Clearly, then, there is no connection between the masses evoked by Cézanne and those of Giotto; they are, rather, antagonists. Giotto seeks to render the actual volume of each thing, its immediate and tangible corporeality. Before his time, one knew only the Byzantine two-dimensional image. Cézanne, on the other hand, substitutes for the bodies of things non-existent volumes of his own invention, to which real bodies have only a metaphorical relationship. After Cézanne, painting only paints ideas—which, certainly, are also objects, but ideal objects, immanent to the subject or intrasubjective.

This explains the hodge-podge that, in spite of misleading interpretations, is inscribed on the muddy banner of so-called *cubism*. Together with volumes that seem to accord major emphasis to the rotundity of bodies, Picasso, in his most typical and scandalous pictures, breaks up the closed form of an object and, in pure Euclidian planes, exhibits their fragments—an eyebrow, a mustache, a nose—without any purpose other than to serve as a symbolic cipher for ideas.

This equivocal cubism is only a special manner within contemporary expressionism. In the impression, we reached the minimum of exterior objectivity. A new shift in the point of view was possible only if, leaping behind the retina—a tenuous frontier between the external and internal—painting completely reversed its function and, instead of putting us within what is outside, endeavored to pour out upon the canvas what is within: ideal invented objects. Note how, by a simple advance of the point of view along the same trajectory it has followed from the beginning, it arrives at an inverse result. The eyes, instead of absorbing things, are converted into projectors of private flora and fauna. Before, the real world drained off into them; now, they are reservoirs of irreality.

It is possible that present-day art has little aesthetic value; but he who sees in it only a caprice may be very sure indeed that he has not understood either the new art or the old. Evolution has conducted painting—and art in general—inexorably, fatally, to what it is today.

The guiding law of the great variations in painting is one of disturbing simplicity. First things are painted; then, sensations; finally, ideas. This means that in the beginning the artist's attention was fixed on external reality; then, on the subjective; finally, on the intra-subjective. These three stages are three points on a straight line.

Now, Occidental philosophy has followed an identical route, and this coincidence makes our law even more disturbing.

Let us annotate briefly this strange parallelism.

The painter begins by asking himself what elements of the universe ought to be translated onto canvas, that is, what class of phenomena is pictorially essential. The philosopher, for his part, asks what class of objects is fundamental. A philosophical system is an effort to reconstruct the universe conceptually, taking as a point of departure a certain type of fact considered as the firmest and most secure. Each epoch of philosophy has preferred a distinct type, and upon this has built the rest of the construction.

In the time of Giotto, painter of solid and independent bodies, philosophy believed that the ultimate and definitive reality were individual substances. Examples given of such substances in the schools were: this horse, this man. Why did one believe to have discovered in these the ultimate metaphysical value? Simply because in the practical and natural idea of the world, every

horse and every man seems to have an existence of his own, independent of other things and of the mind that contemplates them. The horse lives by himself, complete and perfect, according to his mysterious inner energy; if we wish to know him, our senses, our understanding must go to him and turn humbly, as it were, in his orbit. This, then, is the substantialist realism of Dante, a twin brother to the painting of bulk initiated by Giotto.

Let us jump to the year 1600, the epoch in which the painting of hollow space began. Philosophy is in the power of Descartes. What is cosmic reality for him? Multiple and independent substances disintegrate. In the foreground of metaphysics there is a single substance—an empty substance—a kind of metaphysical hollow space that now takes on a magical creative power. For Descartes, the *real* is space, as for Velásquez it is hollow space.

After Descartes, the plurality of substance reappears for a moment in Leibniz. These substances are no longer corporeal principles, but quite the reverse: the monads are subjects, and the role of each—a curious symptom— is none other than to represent a *"point de vue."* For the first time in the history of philosophy we hear a formal demand that science be a system which submits the universe to a point of view. The monad does nothing but provide a metaphysical situs for this unity of vision.

In the two centuries that follow, subjectivism becomes increasingly radical, and toward 1880, while the

impressionists were putting pure sensations on canvas, the philosophers of extreme positivism were reducing universal reality to pure sensations.

The progressive dis-realization of the world, which began in the philosophy of the Renaissance, reaches its extreme consequences in the radical sensationalism of Avenarius and Mach. How can this continue? What new philosophy is possible? A return to primitive realism is unthinkable; four centuries of criticism, of doubt, of suspicion, have made this attitude forever untenable. To remain in our subjectivism is equally impossible. Where shall we find the material to reconstruct the world?

The philosopher retracts his attention even more and, instead of directing it to the subjective as such, fixes on what up to now has been called "the content of consciousness," that is, the intrasubjective. There may be no corresponding reality to what our ideas project and what our thoughts think; but this does not make them purely subjective. A world of hallucination would not be real, but neither would it fail to be a world, an objective universe, full of sense and perfection. Although the imaginary centaur does not really gallop, tail and mane in the wind, across real prairies, he has a peculiar independence with regard to the subject that imagines him. He is a virtual object, or, as the most recent philosophy expresses it, an ideal object.[2] This is the

[2] The philosophy to which Ortega refers, but which unfortunately he neglects to name, is obviously Husserlian phenomenology. (Translator's Note—J.F.)

type of phenomena which the thinker of our times considers most adequate as a basis for his universal system. Can we fail to be surprised at the coincidence between such a philosophy and its synchronous art, known as expressionism or cubism?

Translated from the Spanish by Paul Snodgress and Joseph Frank

IN SEARCH OF GOETHE
FROM WITHIN

Letter to a German

You ask me, my dear friend,[1] for something about Goethe on the occasion of the centenary, and I have tried once or twice to see if I could satisfy your request. It is many years since I have read Goethe—why?—and I began by looking through the serried volumes of his works. But I immediately felt that my goodwill would soon be exhausted, that I could not do what you ask of me. For many reason. Of which the first is this: I am not in favor of centenaries. But—are you? Does any European today find himself in the right frame of mind to celebrate centenaries? This year of 1932 preoccupies us too sternly for us to be able to transfer ourselves bag and baggage to any date of 1832. But that is not the worst of it. The worst of it is that, problematic as our life in 1932 has become, the most problematic thing about it is precisely its relation with the past. People are not clearly aware of this, because the present and the future always afford a more dramatic spectacle. But the fact is that the present and the future have often looked quite as difficult and forbidding as they do today, if not more so. What gives our present situation an unwonted seriousness in human annals arises not from these two dimensions of time but rather from the third. If the European casts up the balance sheet of his situation with some degree of perspicacity, he will find that he despairs, not of the present or the future, but precisely of time past.

Life is an operation which is done in a forward direc-

[1] This essay was written for *Die Neue Rundschau* of Berlin, in 1932, on the occasion of the centenary of Goethe's death.

tion. One lives *toward* the future, because to live consists inexorably in *doing*, in each individual life *making* itself. To call this "doing and making," "action," is only to becloud the terrible reality. "Action" is only the beginning of doing. It is only the moment when one decides what to do, when one makes up one's mind. *Im Anfang war die Tat*[2] is, therefore, a good saying. But life is not only beginning. Beginning is already *now*. And life is continuation, is survival into the moment which will arrive after *now*. Life, therefore, suffers under an inevitable imperative of realization. This necessity for actual realization in the world, beyond our simple subjectivity and intention, is what is expressed by "doing." It obliges us to seek means to survive, to execute the future—whereupon we discover the past as an arsenal of means, receipts, norms. The man who has not lost faith in the past is not frightened by the future, because he is sure that in the past he will find the tactic, the method, the course, by which he can sustain himself in the problematic tomorrow. The future is the horizon of problems, the past is the *terra firma* of methods, of the roads which we believe we have under our feet. Consider, my dear friend, the terrible situation of the man to whom the past, the stable, suddenly becomes problematical, suddenly becomes an abyss. Previously, danger appeared to lie only before him, in the hazardous future; now he finds it also behind his back and under his feet.

[2] "In the beginning was the act."

Are we not undergoing something of the sort ourselves? We believed that we were heirs of a magnificent past, and that we could live on the income of it. We find the future bearing down on us rather harder than it bore down on previous generations, we look back, according to our wont, for the traditional weapons; but when we take them up, we find that they are rubber daggers, inadequate gestures, theatrical "props" which shatter on the hard bronze of our future, of our problems. And suddenly we feel disinherited, traditionless, destitute, as if we were recent emigrants into life, without predecessors. "Patrician" was the Roman term for the man who could make a will and who left an inheritance. The rest were proletarians—descendants, but not heirs. Our heritage consisted in our methods—that is, in the classics. But the European crisis, which is the world crisis, may be diagnosed as a crisis of all classicism. We feel that the traditional ways are useless to solve our problems. People can go on writing books about the classics indefinitely. The easiest thing to do about anything is to write a book about it. The hard thing is to *live on* it. Can we live on our classics today? Is not Europe suffering from a strange proletarization?

The breakdown of the university in the face of men's present needs—the tremendous fact that the university has ceased to be a *pouvoir spirituel* in Europe—is merely a consequence of the same crisis, because the university is classicism.

Is not such a state of affairs the most contrary to the

spirit of centenaries? In a centenary celebration, the rich heir complacently goes over the treasure which past centuries have distilled. But it is a sad and depressing business to go over a treasure of depreciated coins. To do so can only make us more convinced of the inadequacy of the classic. By the crude, demanding, inexorable light of the present vital urgency, the figure of the classic dissolves into mere phrases and boasts. In the last few months we have celebrated the centenaries of two giants—St. Augustine and Hegel—and the results were deplorable. The occasion being what it was, not a single fruitful and animating page could be published on either of them.

Our state of mind is precisely the contrary of that which might inspire us with acts of worship. In the hour of danger, life throws off all inessentials, all excrescences, all its adipose tissue, and tries to strip itself, to reduce itself to pure nerve, pure muscle. Herein lies the salvation of Europe—in a narrowing down to the essential.

Life is, in itself and forever, shipwreck. To be shipwrecked is not to drown. The poor human being, feeling himself sinking into the abyss, moves his arms to keep afloat. This movement of the arms which is his reaction against his own destruction, is culture—a swimming stroke.—When culture is no more than this, it fulfills its function and the human being rises above his own abyss. But ten centuries of cultural continuity brings with it—among many advantages—the great

disadvantage that man believes himself safe, loses the feeling of shipwreck, and his culture proceeds to burden itself with parasitic and lymphatic matter. Some discontinuity must therefore intervene, in order that man may renew his feeling of peril, the substance of his life. All his life-saving equipment must fail, he must find nothing to cling to. Then his arms will once again move redeemingly.

Consciousness of shipwreck, being the truth of life, constitutes salvation. Hence I no longer believe in any ideas except the ideas of shipwrecked men. We must call the classics before a court of shipwrecked men to answer certain peremptory questions with reference to real life.

How would Goethe look before such a court? It might be suspected that he is the most questionable of the classics, because he is the classic to the second power, the classic who in his turn lived by the classics, the prototype of the spiritual heir—a fact of which he was very well aware. In short, among the classics, Goethe represents the *patrician*. This man supported himself on the income of the entire past. In his creation there is a considerable amount of mere administering the wealth he had received; hence, in his life as in his work, there is always the look of Philistinism which an administrator never fails to possess. Furthermore, if all the classics are such, in the last analysis, *for* life, this man claims to be the artist of life, the classic *of* life. More strictly than any other, then, he must justify himself *before* life.

As you see, instead of sending you something for Goethe's centenary, I am, on the contrary, under the necessity of asking you for it. The operation which, it should seem, needs to be performed on Goethe, is too serious and radical to be undertaken by anyone who is not a German. Summon up your courage and perform it! Germany owes us a good book on Goethe. So far, the only readable one is Simmel's; and, like all Simmel's books, it is inadequate because that acute mind—a sort of philosophical squirrel—never considered his subject as a problem in itself, but instead took it as a platform upon which to execute his marvelous analytical exercises. On the other hand, this has been the essential defect of all German books on Goethe: their authors work *on* Goethe, but never question themselves about Goethe, never put Goethe in question, never work *underneath* Goethe. The frequency with which they use the words "genius," "titan," and other contourless vocables which everyone except Germans has left off using, is enough to assure us that their work is all mere sterile Goethean bigotry. Attempt the contrary, my dear friend! Do what Schiller suggested to us: treat Goethe like "a proud virgin, who should be given a child to humiliate her before the world." Write us a Goethe for the shipwrecked.

Nor do I believe that Goethe would refuse thus to be called before a court of vital urgencies. Perhaps this is the most Goethean thing to do with Goethe. Is it not exactly what he did with other things, with everything

else? *Hic Rhodus, hic salta.* Here is life, here the dance must be danced. Anyone who wants to save Goethe must approach him from this direction.

But I do not see that his work can be of benefit today if the problem of his life is not posed in a way different from that heretofore in use. The biographies of Goethe have been built up in accordance with the optics of monuments. Their authors would seem to have been commissioned to create a statue for a public square—or, vice versa, to compose guidebooks for Goethean sightseers. In the last analysis, they are concerned with going *around* Goethe. They are therefore concerned to produce a figure whose external form is extremely clear, which presents no problems to the eye, which is all in sweeping lines. Monumental optics, we may say for the moment, has four disadvantages: it is a solemn vision, seen from outside, seen from a distance, and lacking in genetic dynamism. This monumentalism becomes the more obvious the greater the number of anecdotes and details the biographer furnishes us, because the macroscopic and distant perspective according to which the figure is constructed does not allow us to see them in it, consolidated into its form, and, though we are given them, they have no meaning for us.

The Goethe I ask of you must be constructed in accordance with a contrary optics. I ask you for a Goethe from within.

From within whom? Within Goethe? But . . . *who* is Goethe? I do not know whether you understand my

question. If you ask your own self, strictly and peremptorily, Who am I?—not, What am I? but, Who is that *I* of whom I perpetually talk in my daily life—you will become aware of the incredible manner in which philosophy has always gone astray by giving the name of "I" to the most unlikely things but never to the thing that you call "I" in your daily life. That I which is you, my dear friend, does not consist in your body, nor yet in your soul, your consciousness, or your character. You found yourself with a body, a soul, a character, as you found yourself with the capital which your parents left you, with the country in which you were born, and with the human society in which you move. Just as you are not your liver, be it sound or diseased, neither are you your memory, be it good or bad, nor your will, be it strong or weak, nor your intelligence, be it acute or dull. The I which you are, found itself with these physical or psychical *things* when it found itself alive. You are the person who has to live *with* them, *by means of* them, and perhaps you spend your life protesting against the soul with which you were endowed—of its lack of will, for example—as you protest against your bad stomach or of the cold climate of your country. The soul, then, remains as much *outside* the *I* which you are, as the landscape remains outside your body. Let us say, if you choose, that among the things with which you found yourself, your soul is the closest to you, but it is not you yourself. We must learn to free ourselves from the traditional idea which would have reality always consist in

some *thing*, be it physical or mental. You are no *thing*, you are simply the person who has to live *with* things, *among* things, the person who has to live, not *any* life but a *particular* life. There is no abstract living. Life means the inexorable necessity of realizing the design for an existence which each one of us is. This design in which the I consists, is not an idea or plan ideated by the person involved, and freely chosen. It is anterior to (in the sense of independent form) all the ideas which his intellect forms, to all the decisions of his will. Our will is free *to realize or not to realize* this vital design which we ultimately are, but it cannot correct it, change it, abbreviate it, or substitute anything for it. We are indelibly that single programmatic personage who must be realized. The outside world or our own character makes that realization easier or more difficult. Life is essentially a drama, because it is a desperate struggle— with things and even with our character—to succeed in being in fact that which we are in design.

This consideration permits us to give a biography a different structure from the usual one. Until now, the biographer at his most perspicacious has been a psychologist. He has had the gift of entering *into* a man and discovering all the clockwork which forms the character and, in general, the soul of his subject. Far be it from me to disdain these investigations. Biography requires psychology as it requires physiology. But all that is pure information.

We must get over the error which makes us think

that a man's life takes place inside himself and that, consequently, it can be reduced to pure psychology. Would that our lives did take place inside ourselves! Then life would be the easiest thing imaginable: it would be to float in its own element. But life is as far as possible from a subjective phenomenon. It is the most objective of all realities. It is a man's *I* finding itself submerged in precisely what is not himself, in the pure *other* which is his environment. To live is to be outside oneself, to realize oneself.—The vital program which each one of us irremediably is, overpowers environment to lodge itself there. This unity of dramatic dynamism between the two elements, the I and the world—is life. Hence it forms a circumference within which are the person, the world, and . . . the biographer. For this is the real *within* from which I wish you to look at Goethe. Not the within of Goethe, but the within of his life, of his drama. It is not a matter of seeing Goethe's life *as* Goethe saw it, with his subjective vision, but of entering, *as* biographer, into the magic circle of that phenomenon to witness the momentous objective event which that life was, and of which Goethe was only one ingredient.

Nothing can so properly be called *I* as that programmatic personage, because upon its peculiarity depends the value which all *our* things—our body, our soul, our character, our circumstances—finally assume in our life. They are ours through their favorable or unfavorable relation to the personage who has to be realized. For

this reason, it cannot be said that two different men find themselves in the same situation. The disposition of things around them, which abstractly would seem to be identical, responds differently to the different inner destiny which is each of them. I am a certain absolutely individual pressure upon the world: the world is the no less definite and individual resistance to that pressure.

A man—that is, his soul, his gifts, his character, his body—is the sum of organs *by* which his life is lived; he is therefore equivalent to an actor bidden to represent the personage which is his real I. And here appears the most surprising thing in the drama of life: a man possesses a wide margin of freedom with respect to his I or destiny. He can refuse to realize it, he can be untrue to himself. Then his life lacks authenticity. If "vocation" is not taken to mean what it commonly does— merely a generic form of professional occupation, of the civil *curriculum*—but to mean an integral and individual program of existence, the simplest thing would be to say that our I is our vocation. Thus we can be true to our vocation to a greater or lesser degree, and consequently have a life that is authentic to a greater or lesser degree.

If the structure of human life is viewed in this light, the most important problems for a biography will be the two following, which have not as yet been much considered by biographers. The first consists in determining what the subject's vital vocation was, though it is entirely possible that he was never aware of it. Every

life is, more or less, a ruin among whose debris we have to discover what the person ought to have been. This obliges us to construct for ourselves—as the physicist constructs his "models"—an imaginary life of the individual, the graph of his successful life, upon which we can then distribute the jags (they are sometimes enormous) which external destiny inflicted. We all feel our real life to be a deformation—sometimes greater, sometimes less—of our possible life. The second problem is to weigh the subject's fidelity to this unique destiny of his, to his possible life. This permits us to determine the degree of authenticity of his actual life.

The matter of the greatest interest is not the man's struggle with the world, with his external destiny, but his struggle with his vocation. How does he behave when faced with his inexorable vocation? Does he subscribe to it basically; or, on the contrary, is he a deserter from it, does he fill his existence with substitutes for what would have been his authentic life? Perhaps the most tragic thing about the human situation is that a man may try to supplant himself, that is, to falsify his life.—Do we know of any other reality which can be precisely what it is not, the negation of itself, the void of itself?

Do you not think it would be worth while to construct a life of Goethe from this point of view, which is the truly inner point of view? Here the biographer enters into the unique drama which every life is, feels himself submerged in the pure dynamisms, agreeable or painful,

which constitute the actual reality of a human existence. A life viewed in this way, from its inwardness, has no "form." Nothing seen from within has form. Form is always the external appearance which a reality offers to the eye when the eye contemplates it from outside, making it a mere object. When something is merely an object, it is merely an appearance for another and not a reality for itself. Life cannot be a mere object, because it consists precisely in its execution, in being actually lived, and hence being never concluded, never definitive. It does not allow itself to be contemplated from without: the eye must transport itself there and *make reality itself its point of view.*

We are a little tired of the statue of Goethe. Penetrate into his drama—renouncing the conventional and sterile beauty of his figure.—Our body viewed from within has not that which is commonly called form and which, properly speaking, is merely external and macroscopic form; it has only *feinerer Bau,* microscopic tissue structure, and, in the final analysis, pure chemical dynamism. Give us a Goethe who is shipwrecked in his own existence, who is lost in it and never knows from one minute to the next what will become of him—the Goethe who felt that he was "like a magic oyster over which strange waves pass."

Is it not worth attempting something of the sort in a case like this? Because of the celebrity or the value of Goethe's work, we possess more data concerning his existence than we probably do concerning any other

human being. We can therefore—that is to say, *you* can, because I know very little about Goethe—work *ex abundantia*.

But there is another reason for making the attempt precisely with Goethe. He is the man in whom for the first time there dawned the consciousness that human life is man's struggle with his intimate and individual destiny—that is, that human life is made up of the problem of itself, that its substance consists not in something that already *is*—like the substance of the Greek philosopher and, more subtly but in the last analysis equally, that of the modern idealist philosopher—but in something which has to make itself, which, therefore, is not a *thing* but an absolute and problematical *task*. That is why we see Goethe perpetually scrutinizing his own life. It is as idle to attribute this obsession to egotism as it is to interpret it "artistically" and present us with a Goethe making his own statue. Art, all art, is a highly respectable matter, but it is superficial and frivolous if it is compared with the terrible seriousness of life. Let us therefore avoid lightly referring to an art of life. Goethe is perpetually preoccupied with his life, simply because life *is* preoccupation with itself.[3] His

[3] Heidegger's admirable book, *Being and Time*, published in 1927, arrives at a definition of life not far from this. It would be impossible for me to say how close Heidegger's philosophy comes to that which has always inspired my writings—among other things, because Heidegger's work is not yet finished, nor, on the other hand, have my ideas been adequately developed *in print*. But I am obliged to say that I owe Heidegger very little. Of Heidegger's important concepts, but one or two at most have not been previously expressed

understanding of this fact makes him the first of our contemporaries, if you like, the first of the Romantics. Because that is what, under its literary-historical significations, Romanticism means: the preconceptual dis-

in one of my books, sometimes thirteen years earlier. For example: the idea of life as uneasiness, preoccupation, and insecurity, and of culture as security and preoccupation with security, is literally to be found in my first work, *Meditaciones del Quijote*,—published in 1914!—in the chapter entitled "Cultura-seguridad," pp. 116-117. Furthermore, this thought is there first applied to the history of philosophy and culture, in the particular case of Plato, which is of such significance for the theme. The same is true of liberation from all "substantialism," from all that is "thing," in the idea of being— supposing that Heidegger has arrived at it as I have set it forth for many years in public lectures and as it is stated in the prologue to this first book of mine, page 42, and developed in my various expositions of perspectivism (though today I prefer to use more dynamic and less intellectual terms than this). Life as the confrontation of the I and *its* environment (cf. p. 43), as a "dynamic dialogue between the individual and the world," in many passages. The structure of life as futurition is the most persistent *leitmotiv* of my writings, inspired, certainly, by questions raised by the logic of Cohen but which are extremely remote from the vital problem to which I apply it. Likewise: "In sum, the resorption of the environment is the concrete destiny of man," page 43, and the theory of the "incorruptible base," which I soon afterward called the "authentic I." Even the interpretation of truth as *aletheia*, in its etymological sense of "disclosure, unwrapping, removing a veil or covering," is to be found on page 80, with the additional circumstance that in this book cognition, under the names of "light" and "clarity" (which are now so much in evidence!), already appears as the imperative and mission enclosed "in the root of the *constitution of man.*" I confine myself to making these remarks once and for all, since from time to time I find myself surprised that not even those who are closest to me have the faintest idea of what I have thought and written. Distracted by my images, they have slipped over my ideas. I am enormously indebted to German philosophy and I hope that no one will fail to credit me with having made it one of the principal features of my work to swell the thought of Spain with the full stream of German intellectual riches. But per-

covery that life is not reality which encounters a greater or lesser number of problems, but that it consists exclusively in the problem of itself.

Obviously Goethe throws us off the track because his

haps I have exaggerated this attitude and have too much concealed my own and basic findings. For example: "To live is certainly to deal with the world, to turn to it, to act in it, to be concerned with it." Whose is that? Heidegger's, in 1927, or mine, published under date of December 24, 1924, in *La Nación*, of Buenos Aires, and later in Volume VII of *El Espectador* ("El origen deportivo del Estado")? Because the important thing is that this formula is not accidental but is the starting point—no less—for my suggestion that philosophy is consubstantial with human life, because human life has to go out into the "world," which already in those early paragraphs of mine, signifies not the sum of things but the "horizon" (*sic*) of totality *above* things and distinct from them. To find here such facts as I have transcribed in this note will perhaps bring some slight feeling of shame to young men who were ignorant of them *in good faith*. If it were a matter of *bad faith*, it would be of no importance; the important thing for them is to discover that they were ignorant of them in good faith, with the result that they must become doubtful of their good faith. Strictly, all these observations are comprised in one, which I have always kept to myself and which I shall now laconically make. In 1923 I published a book which—with a certain solemnity which my present maturity would urge me to avoid—was entitled *The Theme of our Time*. In this book, no less solemnly, I said that the theme of our time consists in reducing pure reason to "vital reason." Has anyone yet tried—not to draw the most immediate consequences from this phrase, but simply to understand its meaning? People have gone on talking, despite my protests, about my vitalism, but no one has tried to think of the terms "reason" and "vital" in juxtaposition, as my formula proposes. No one, in short, has talked about my "ratio-vitalism." And even now, after I have emphasized it, how many can understand it, can understand the *Critique of Vital Reason* which was announced in that book?

As I have kept silence for many years, I shall return to silence for many more, with no further interruption than this hurried footnote, which really does nothing but set any strayed good faith on the right path.

ideal of life is biological, botanical. Like all the past, he has an external conception of life. But this means only that the ideas which a man conceives are superficial compared with his vital, pre-intellectual verity. Goethe thinks of his life under the image of a plant, but he feels it, he *is* it, as a dramatic preoccupation with his own self.

I am afraid that this botanism of Goethe as a thinker makes him sterile for the demands of modern man. On the other hand, we can profit by a number of the terms he used. When, undertaking to answer the same question I put before—that agonizing Who am I?—he replied: An *entelechy*, he used what is perhaps the best word to designate that vital design, that inexorable plan, in which our real I exists. Each one of us is "he whom he has to become," although perhaps he never succeeds in becoming anything. Can this be expressed by one word better than it is expressed by the word "entelechy"? But the ancient vocable carries with it a millennial biological tradition which gives it a smack of the zoo, the connotation of something torpid, of something extrinsic, of an organic force magically ingrafted into animal and plant. Goethe furthermore weakens the question, *Who* am I? into the traditional *What* am I?

But beneath his official ideas, we come upon a Goethe laboriously groping after the mystery of the authentic I which lies behind our actual life like its mysterious root, as the hand lies behind the thrown dart, and which cannot be conceived under any of the external and cosmic categories. Thus in *Poetry and Reality*: "All

men of good breeding feel, as their culture increases, that they are called upon to play a twofold role in the world, one real and the other ideal, and in this feeling is to be sought the foundation of everything noble. What the real role that has been given us is, and in what it consists, we clearly discern. On the other hand, it is very rarely that we succeed in reaching clarity concerning the second role. However much a man searches heaven and earth, the present and the future, for his higher destiny, he remains the victim of a perennial vacillation, of an external influence which perpetually troubles him until, once and for all, he makes up his mind to declare that right is that which accords with him."

The I which is our vital design, "that which we are to be," is here called *Bestimmung*. But this word suffers from the same ambiguities as "destiny" (*Schicksal*). What is our destiny—the inner or the outer, that which we were to be, or that which our character and the world force us to be? Goethe therefore distinguishes between our real—that is, actual—destiny, and our ideal or higher destiny, which is, as we have seen, our authentic destiny. The other arises from the deformation which is inflicted on us by the world, "with its perpetually troubling influence," which leads us astray with respect to our true destiny.

Nevertheless, Goethe here remains imprisoned within the traditional idea which confuses the I which each must be, whether he will or not, with a generic, norma-

tive I which "ought to be"—individual and inescapable destiny with the "moral" destiny of man (which is merely a concept by which man tries to justify his existence), with the abstract meaning of the species. This dichotomy, this state of confusion, into which he is driven by tradition, is the cause of his "perennial vacillation" (*ewigen Schwanken*), because our moral destiny will always be subject to dispute, as is everything "intellectual." He feels that the primary ethical norm cannot be a juxtaposition of life with something which life can definitely set aside. He half sees that life is in itself ethical, in a more basic sense of the word, that in man the imperative forms a part of his own reality. The man whose entelechy is, let us say, to be a thief has to be one, even though his moral ideas are opposed to it, suppress his unchangeable destiny, and manage to make his actual life that of a law-abiding citizen. It is a terrible thing, but there is no denying it: the man who *had to be* a thief and, by a virtuous effort of will succeeds in not being one, falsifies his life.[4] So let there be no confounding the *ought to be* of morality, which inhabits man's intellectual region, with the vital imperative, the *has to be* of personal vocation, situated in the most profound and primary region of our being. All the things of the intellect and the will are secondary, are actually a reaction provoked by our basic being. If the human

[4] The critical question is whether, in effect, being a thief is a form of authentic humanity—that is, if the "born thief" exists in a sense much deeper than Lombroso's.

intellect functions, it is actually in order to solve the problems which the man's inner destiny sets it.

It is through this that, at the end of the paragraph, Goethe emerges from his confusion: "right is what accords with" the individual (*was ihm gemäss ist*). For the imperative of intellectual and abstract ethics is substituted the inner, concrete, vital imperative.

Man recognizes his I, his unique vocation, only through the liking or aversion aroused in him by each separate situation. Unhappiness, like the needle of a registering apparatus, tells him when his actual life realizes his vital program, his entelechy, and when it departs from it. So Goethe to Eckermann in 1829: "Man, with all his preoccupations and efforts, is delivered over to the outward, to the world around him, and must try to know it and make it serviceable to him to the extent required by his ends. But concerning himself he knows only when he is satisfied and when he suffers, and only his sufferings and his satisfactions instruct him concerning himself, teach him what to seek and what to avoid. For the rest, man is a confused creature; he knows not whence he comes or whither he goes, he knows little of the world, and above all, he knows little of himself."

Only his sufferings and his satisfactions instruct him concerning himself. Who is this "himself" which is only discernible *a posteriori*, in its collision with what befalls it? Obviously it is our life-design, which, in the case of suffering, does not coincide with our actual life:

the man is torn apart, is cut in two—the man who had to be and the man he came to be. Such a dislocation manifests itself in the form of grief, anxiety, ennui, depression, emptiness; coincidence, on the contrary, produces the prodigious phenomenon of happiness.

It is surprising that no one has emphasized the constant contradiction between the ideas which Goethe as a thinker held about the world (the least valuable part of his work: his Spinozan optimism, his *Naturfrömmigkeit*, his botanical image of life, according to which everything in life should proceed calmly, with no painful straying from the road, in accordance with a gentle cosmic necessity) and his own life, including his work. For plant, animal, or star, to live is to have no doubts concerning its own being. None of them has to decide what it will be the next instant. Thus their life is not drama but . . . evolution. But man's life is exactly the opposite: it is having to decide every moment what he must do the next moment, and, therefore, having to discover the very plan, the very design of his being. The extent to which Goethe has been misconceived is almost laughable. The man spent his life searching for himself or avoiding himself—which is quite the opposite of trying to realize himself exactly. The latter presupposes that one has no doubts as to *who* one is, or that, once this is determined, the individual resolves to realize himself—whereupon the attention can tranquilly see to the details of executing the design.

An enormous part of Goethe's work—his *Werther*,

his *Faust*, his *Meister*—presents us with beings who go about the world searching for their inner destiny or . . . fleeing from it.

I do not wish to go into particulars, for that would imply a claim to be well versed in Goethe—and you must not forget that these pages are written on the contrary supposition: they are questions which I put to you; they are problems which I ask you to clarify. In this sense, I permit myself to manifest extreme surprise at the fact that it is regarded as the most natural thing in the world that a man who developed so early as Goethe, who had created—though he had not completed—all his great works before he was thirty, is to be found, on the verge of forty, still asking himself, as he wanders through Italy, whether he is poet, painter, or scientist, and writing from Rome on March 14, 1788: "For the first time I have found myself and am happily in harmony with myself." And the most serious aspect of the case is that even then, apparently, he was wrong and will go on wandering for decades in search of the "self" which he supposed he had found in Rome.

What constituted tragedy used to be that a terrible exterior fate fell upon a man, a fate so unequivocal and inevitable that the unfortunate man succumbed under it. But the tragedy of Faust and the story of Meister are exactly the opposite: in both, what constitutes the drama is that a man sets out in search of his inner destiny and goes wandering through the universe without ever finding his own life. In the former case,

life encounters problems; in the latter case, life itself is the problem. What befalls Werther, Faust, and Meister is what befalls the *Homunculus*: they want to be and they do not know how—that is, they do not know *who* to be. The solution which Goethe furnishes for Meister —suddenly dedicating him to medicine—is unworthy of its author; it is as arbitrary and frivolous as if Goethe himself had remained in Rome forever, copying the mutilated torsos of antique statues. Destiny is precisely that which is not chosen.

The German professors have made stupendous efforts to give a decent appearance to what these works of Goethe's *are* and to his ideas about life—without, obviously, attaining their conventional goal. It would be far more fruitful to attempt the very opposite: to start from the obvious contradiction between this optimistic concept of nature, this confidence in the cosmos, which inspires all Goethe's relations with the universe, and the constant, painful preoccupation with his own life, with himself, which will not let him relax for an instant. Only after this contradiction has once been recognized is there revealed to us the fecund task of trying to solve it, of explaining it systematically. That is what biography is: a system in which the contradictions of a human life are unified.

You see by now that I have an unduly naïve idea of Goethe. Perhaps because I do not know him well, everything about him presents itself to me as a problem. Even the smallest details of his physical person and of

his adventures puzzle me. For example: I fail to under-
stand why his biographers do not try to explain to us
why this man, who seems to have had such a fortunate
life in every way, should be the human being concerning
whom we have documentary evidence that he spent
most days in a state of depression. The external circum-
stances of his life *appear*—at least so his biographers
assure us—favorable; in character he was jovial, posi-
tively a *Frohnatur*. Then why such frequent depres-
sions?

> *"So still und so sinnig!*
> *Es fehlt dir was, gesteh es frei."*
> *"Zufrieden bin ich,*
> *Aber mir ist nicht wohl dabei."*[5]

Persistent depression is only too clearly a sign that a
man is living contrary to his vocation.

I say the same of his famous "rigidity," his perpen-
dicular walk. Goethe's character has an admirable
elasticity which gives him a limitless power of accom-
modation. His versatility, his wealth of nuances, his
awareness of his surroundings, are prodigious gifts.
Then why, nevertheless, is he stiff, rigid? Why did he
walk among people holding his body like a banner
borne in procession? Let it not be said that this is of no
importance. "A man's appearance is the best text for

[5] *"So silent and thoughtful!*
You lack something—admit it."
"I am content,
But content does not put me at ease."

anything that can be felt or said about him." (Stella.)
I assume that it is not improper for me to urge you to
dedicate a "physiognomic fragment" to Goethe! I es-
pecially recommend to you the Diary of Friederike
Brion—July 7 to 12, 1795—"a bitter apathy rests on
his brow like a cloud." And particularly what follows—
which I do not transcribe so that I shall not feel obliged
to tell you what I think about it. Neither should you
forget "some unpleasant lines about his mouth," of
which Leisewitz speaks in his Diary—August 14, 1780
—and which can be perfectly seen in almost all of
Goethe's juvenile portraits.

I fear that if you follow my suggestions you will
cause a great scandal in Germany, because the Goethe
who would emerge would be approximately the op-
posite of the one portrayed in the gospels so far pro-
duced by the German press. Nothing, indeed, could be
more heterodox than to present Goethe as a man full
of marvelous gifts, with magical springs of enthusiasm,
with a splendid character—energetic, pure, generous,
and jovial—but . . . perpetually untrue to his destiny.
Hence his depressions, his stiffness, his distance from
his surroundings, his bitterness. It was a life *à rebours*.
His biographers are satisfied to watch his gifts and his
character function—both of which are indeed admirable
and offer an enchanting spectacle to anyone who looks
at the surface of Goethe's existence. *But a man's life is
not the operation of the exquisite mechanisms which
Providence put inside him.* The crucial question is to ask

oneself in *whose* service they operate. Was the man Goethe in the service of his vocation, or was he, rather, a perpetual deserter from his inner destiny? Naturally, I am not going to solve this dilemma. Therein lies the serious and radical operation to which I alluded before, and which only a German can undertake.

But I do not need to conceal my impression—perhaps unfounded, probably naïve—that in Goethe's life there are too many flights. He begins by fleeing from all his real loves, which are those of his youth. He flees from his life as a writer to fall into that unhappy Weimar episode—Weimar is the greatest *malentendu* in German literary history; who knows but that it prevented German literature from being the finest literature in the world! Yes! even if at first sight this appears to you to be an error, an intolerable paradox, and even if it should prove to be so in the long run—believe me, I have plenty of reasons for being guilty of it! But when Goethe flees from Weimar, which was already itself a flight, and this time his flight even has the material, police-blotter tokens of a flight: he flees from Aulic Councillor Goethe to Jean Philippe Möller, merchant, who presently becomes a forty-year-old student of painting in Rome.

His biographers, determined as ostriches to gather all the stones in the Goethean landscape as if they were roses, undertake to make us believe that in his amorous flights Goethe fled from what was not his destiny in order to remain all the more faithful to his authentic vocation. But what was his authentic vocation?

I am not going to abuse your patience by developing the theory of vocation for you—it implies a whole philosophy. I should only like to call to your attention the fact that a vocation, although it is always individual, is obviously composed of numerous generic ingredients. However much of an individual you may be, my dear friend, you have to be a man, to be a German or a Frenchman, to be of one period or another, and each one of these designations brings in its train a whole repertory of definite destinies. However, all this is not properly destiny until it has been individually modulated. Destiny is never abstract and generic, although not all destinies have the same degree of concretion. One man is born into the world to fall in love with a single and particular woman, and, consequently, it is not likely that he will find her. Fortunately, most men have a less differentiated amatory destiny and can actualize their sentiments with vast legions of homogeneous femininity—as who should say, one with blondes, another with brunettes. When we speak of life, every word must be completed by the appropriate index of individuation. This deplorable necessity is indeed a part of man's destiny as man: to live *in particular* he has to speak *in general*.

Goethe's vocation! If one thing in the world is clear, this is that thing! Certainly, it would be a fundamental error to believe that a man's vocation coincides with his most indisputable gifts. Schlegel said: "Where there is pleasure in a thing, there is a talent for it." What he so absolutely affirms is highly questionable. The same is

true if the proposition is inverted. No doubt the exercise of an outstanding capacity commonly evokes delight automatically. But this pleasure, this automatic delight, is not the happiness of a destiny fulfilling itself. Sometimes a man's vocation does not run in the direction of his gifts, sometimes it runs contrary to them. There are cases—such as Goethe's—in which the multiplicity of gifts troubles and disorients the vocation, or at least the man who is its axis.

But setting all casuistry aside, it is more than evident that Goethe's destiny was basically to soar and sing. He appeared on this planet with a mission—to be the German writer on whom it devolved to revolutionize his country's literature and, through it, the literature of the world.[6] Given more leisure and more space, we could make our definition considerably more concrete. If we give Goethe's work a vigorous shake, we shall be left with a number of truncated lines which we can complete in our imagination as our eyes complete the broken bow which displays its stump against the sky. To do so will give us the authentic outline of his literary mission.

The Goethe of Strasburg, Wetzlar, Frankfurt still gives us reason to say: *"Wie wahr, wie seiend!"*[7] De-

[6] I stress the fact that this is only the generic expression of his vocation and even that only in reference to what may be considered the axis of it. Adequate clarity concerning what is here suggested to the well-disposed reader, can only be achieved by developing the theory of vocation.

[7] "How full of truth, how full of being!"—Goethe's remark on a crawfish which he saw moving in a brook in Italy.

spite his youth and the fact that youth means "not yet to be."

But Goethe accepts the Grand Duke's invitation. At this point I propose that you imagine a Goethe without Weimar—a Goethe thoroughly immersed in the life of the Germany of that epoch, a Germany all ferment, all rising sap, all open pores; a wandering, weather-beaten Goethe, with his material basis (economic and social) *insecure*, without a neat set of boxes filled with duly filed engravings, about which he perhaps never says anything interesting. In other words, the opposite of a Goethe enclosed at the age of twenty in the sterile flask of Weimar and magically desiccated into a *Geheimrat*. Life is our reaction to the basic insecurity which constitutes its substance. Hence it is an extremely serious matter for a man to find himself too much surrounded by apparent securities. A consciousness of security kills life. Herein lies the cause of the regularly recurring degeneration of aristocracies. What a delight to humanity an insecure Goethe would have been, a Goethe distressed by his surroundings, forced to realize his fabulous inner potentialities!

At the moment when the heroic springtime of an authentic German literature begins to appear in that sovereign soul, Weimar isolates him from Germany, tears his roots from German soil, and transplants him to the humus-less flowerpot of a Lilliputian court. A stay at Weimar—Weimar as a watering place—would have been fruitful for him. The German literature

which only Goethe could have renewed, is characterized by the union of violence and measure—*Sturm und Mass*. The *Sturm* of feeling and imagination, two things which other European literatures lack; the measure which—in different forms—France and Italy possess in abundance. Between 1770 and 1830 any German of the first rank could provide the factor of *Sturm*. What is post-Kantian philosophy but a prodigious *Sturm!* But usually the German is nothing but *Sturm*—he is without measure. His way of being what he is, always follows an orbit which the *furor teutonicus* renders eccentric. Imagine a moment when—not to mention the poets —Fichte, Schelling, Hegel should *also* have been endowed with *bon sens!* Well—by some fabulous chance, Goethe united both potentialities. His *Sturm* had developed sufficiently. It was time to encourage the other factor. Goethe was conscious of this. So he went to Weimar to take a few semesters of "Iphigenia-ism." So far so good. But—why, when his feet were so apt at running away, did he stay? Worse yet—ten years later he *did* run away, but he came back. His brief flight is, as it were, documentary proof that Goethe *ought* to have forsaken the court of Charles Augustus. We can follow, almost day by day, the petrifying effect which Weimar had on him. The man is slowly changed into a statue. Statues are men who can neither breathe nor sweat, because they have no atmosphere—a lunar fauna. Goethe begins to live in a direction contrary to his destiny, he begins a process of *de-vivification*. Measure be-

comes excessive and supplants the substance of his destiny. Goethe is a fire which needs a great deal of wood. In Weimar, just as there is no atmosphere, so there is no wood; Weimar is a geometric figure, the Grand Duchy of Abstraction, of Imitation, of the non-authentic. It is the kingdom of the *quasi*.

There is a little Andalusian town that lies on the Mediterranean coast and has an enchanting name—Marbella. The side of my family which I most resemble physically—not morally—my Andalusian and bull-fighter side, has its origin there. In that town, until about a quarter of a century ago, there lived a few families of ancient lineage who, despite the fact that they dragged out a miserable existence, stubbornly insisted upon behaving like noblemen of past ages and celebrated ghostly festivals of anachronistic pomp. On the subject of one of these festivals, the folk of the vicinity composed a quatrain:

> *In a* quasi *city*
> *Certain* quasi *gentlemen*
> *Riding* quasi *horses*
> *Held a* quasi *tournament.*

Not now can we say of Goethe, as we said earlier, *"Wie seiend!"*[8] except for brief escapades, during which, for a moment, he lets himself be carried away by his destiny, and which confirm our hypothesis. His life acquires that strange appearance of being unsatisfied with itself, of leaving itself hungry. Whatever he

[8] "How full of being!"

is, it is neither basically nor wholly: he is a minister who is not seriously a minister, a *régisseur* who detests the theater, who is not properly a *régisseur*, a naturalist who does not succeed in being one; and though, by particular divine decree, he is irremediably a poet, he will force the poet he is to visit the Ilmenau mine and recruit soldiers there, riding an official horse named "Poetry." (I should be much obliged to you if you could manage to prove that this *quasi*-horse is a pure invention fabricated by some ill-wisher.)

It is a terrible example of how a man can have but *one* authentic life, the life which his vocation demands of him. When his freedom induces him to deny his irrevocable *I* and arbitrarily substitute some other for it—arbitrarily, even though in accordance with the most respectable "reasons"—he leads a spectral, unsatisfied life between . . . "poetry and reality." Having accustomed himself to such a life, Goethe ends by no longer needing reality and—as, for Midas, everything turned to gold—so, for Goethe, everything evaporates into a symbol. Hence the extraordinary *quasi*-loves of his maturer years. Even his early relation with Charlotte von Stein is equivocal—we should not understand it if his *quasi*-adventure with Marianne Willemer did not definitely reveal to us the capacity for irreality to which he had attained. Once the idea that life is a symbol is accepted, one thing is as good as another: it is as good to sleep with "Christelchen" as, in the "ideal-Pygmalionic"[9] sense, to marry a statue in the Palazzo Caraffa

[9] See the *Journey to Italy*, Rome, April, 1788.

Colobrano. But destiny is precisely the opposite of the "as good as" of symbolism!

Here we can discern the origin of an idea. All our ideas are reactions—positive or negative—to the situations with which our destiny confronts us. Goethe, as a man who lives a life different from his own, who supplants himself, is obliged to justify himself to himself. (I cannot now demonstrate to you why self-justification is one of the essential components of every life, be it authentic or false. A man *cannot* live without justifying his life to himself, he cannot even take a single step.) Hence the myth of symbolism. I am not discussing its truth or lack of truth in any of its many possible senses. I am interested solely in its genesis and its *vital* truth.

"I have regarded my motives and my efforts as merely symbolical, and at bottom it was a matter of comparative indifference (*ziemlich gleichgültig*) to me whether I found myself making pots or pans." These words, which have so often been commented upon, wing their way out of Goethe's old age and settle gracefully on his youth, on Werther's grave. They are bloodless Wertherism. What the pistol did there, indifference does here. In either case, we are dealing with a man who refuses to live his destiny. If all that a man does is mere symbol, what is the definite reality which is symbolized in it, in what does his authentic task consist? If what he *has to do*, his task, is neither pots nor pans, it must be something else. What? What is true life, according to Goethe? Obviously something that will be

to any concrete life what the *Urpflanze* ("proto-plant") is to each individual plant—the mere form of life, without its determinate contents. My friend, it is impossible that there should be a more complete reversal of the truth. Because living is precisely the inexorable necessity to make oneself determinate, to *enter into an exclusive destiny*, to accept it—that is, to resolve to *be it. We have*, whether we like it or not, to realize our "personage," our vocation, our vital program, our "entelechy" —there is no lack of names for the terrible reality which is our authentic I. This means that living is essentially an imperative basically opposite to that which Goethe proposes to us when he urges us to withdraw from the concrete periphery where life delineates its *exclusive* contour, toward its abstract center—towards the *Urleben*, "proto-life." From actual being to mere potential being. Because that is what the *Urpflanze* and the *Urleben* are: limitless potentiality. Goethe refuses to enclose himself in a destiny which, as such, excludes all other possibilities except one. Goethe wants to remain . . . available. Perpetually. His vital consciousness, which is something more profound and primitive than *Bewusstsein überhaupt* ("consciousness in general") makes him feel that this is the great sin and he tries to justify himself to himself. How? By corrupting himself with two ideas. One, the idea of activity (*Tätigkeit*). "You have to *be!*" life said to him, for life always has a voice and is therefore vocation. And he defended himself: "But I *am*, since I perpetually *act*: I make pots, I

make pans; I never rest for an instant." "That is not enough!" life went on. "What matters is not pots and pans. It is not enough to *act*; you have to *make* your *I*, your absolutely individual destiny. You have to make up your mind irremediably. To live fully is to be something irrevocably." Whereupon Goethe, the great magician, tried to enchant life with the beautiful song of the other idea: symbolism. "True life is the *Urleben* which renounces (*entsagen*) subjecting itself to a determinate form," sang Wolfgang deliciously to his accusing heart.

We can understand why, in his first and sincere impression of Goethe, before he was captured by the charm that Goethe exercised on his intimates, Schiller despaired of the Weimar courtier. Schiller is completely the opposite—infinitely less gifted than Goethe, but his sharp profile is the beakhead of a war galley, with which he cleaves the foamy sea of life and unhesitatingly grapples himself to his destiny. And Goethe? *"Er 'bekennt' sich zu Nichts."* "He commits himself to nothing." *"Er ist an Nichts zu fassen."* "There is no laying hands on him."

Hence Goethe's eagerness to defend to himself an idea of all reality *sub specie aeternitatis*. As there is a proto-plant and a proto-life, there is a proto-poetry, without time or place or mannerism. All Goethe's life is an attempt to manumit himself from serfdom to the spatio-temporal glebe, from the concreteness of destiny in which, precisely, life consists. He aspires to utopism and uchronism.

This produces a most curious human deformation in him. He had been the man to originate a poetry produced from within the human being's individual reality, from within that most personal I which is immersed in its world, in its external destiny. But he swims so directly against the current of his vocation that he ends by being unable to produce anything *from within* himself. To create, he has first to imagine himself as other than he is—a Greek, a Persian—pots, pans. Because these are Goethe's most subtle but most significant flights: his flight to Olympus, his flight to the East. He cannot create from within his irrevocable I, from within his Germanity. Inspiration has to take him unawares, for a new idea to lay hold on him and bring forth *Hermann und Dorothea*. Even so, he presents it with the orthopedic apparatus of the hexameter, which interposes its foreign framework between the original inspiration and the work, forcing upon it a remoteness, a solemnity, a monotony which emasculate it and which give it in exchange . . . the *species aeternitatis*.

The fact is that *there is no species aeternitatis*. And not fortuitously. What there *is*, is the real, *what composes destiny*. And the real is never *species, aspect, spec*tacle, an object of contemplation. All that is precisely the unreal. It is our idea, not our being. Europe needs to cure itself of its "Idealism"—which is also the only way to overcome all materialism, positivism, utopism. Ideas are always too close to our whim, are obedient to it—they are always revocable. We have, no

doubt, increasingly to live *with* ideas—but we must stop living *from* our ideas and learn to live *from* our inexorable, irrevocable destiny. Our destiny must determine our ideas, and not vice versa. Primitive man was lost in the world of things, there in the forest; we are lost in a world of ideas which show us existence as a cupboard full of equivalent possibilities, of things comparatively indifferent, of *Ziemlichgleichgültigkeiten.* (Our ideas—that is, culture. The present crisis is less a crisis of culture than of the position we have given to culture. We have set it before and above life, when it ought to be behind and below life—because it is a reaction to life. We must now stop putting the cart before the horse.)

Life consists in giving up the state of availability. Mere availability is the characteristic of youth faced with maturity. The youth, because he is not yet anything determinate and irrevocable, is everything potentially. Herein lies his charm and his insolence. Feeling that he is everything potentially he *supposes* that he is everything actually. The youth does not need to live on himself: he lives all other lives potentially—he is simultaneously Homer and Alexander, Newton, Kant, Napoleon, Don Juan. He has *inherited* all these lives. The youth is always a *patrician*, always the "young master." The growing insecurity of his existence proceeds to eliminate possibilities, matures him. But try to picture to yourself a man whose youth surrounds him with conditions of abnormal security. What will hap-

pen? Probably he will never cease to be a youth, his tendency to remain "available" will be flattered and encouraged and finally fixed. In my opinion, this is the case with Goethe. In him, as there usually is in great poets, there was an organic predisposition to remain a youth forever. Poetry is adolescence fermented and thus preserved. Hence those sudden returns of eroticism in Goethe's old age, accompanied by all the youthful symptoms—joy, melancholy, writing poems. For such a temperament, the external situation in which the end of his youth found him was decisive—I mean his first youth, the original one. This, usually, is the first time that we feel the pressure of our surroundings. Serious economic difficulties begin, the struggle with the rest of mankind begins. The asperity, the bitterness, the hostility of our mundane environment appear. This first attack either forever annihilates our heroic resolve to be what we secretly are and gives birth to the Philistine in us; or, on the other hand, in the collision with the *counter-I* which the universe is, our I is revealed to itself, resolves to be, to impose itself, to stamp its image on external destiny. But if at this period, instead of coming against the world's resistance for the first time, we find it giving way before us, roused to no waves by our passage, fulfilling our desires with magic docility, our I will fall voluptuously asleep; instead of being revealed to itself, it remains vague. Nothing so saps the profound resources of a life as finding life too easy. Such was Weimar for Goethe at that decisive period. Weimar

made it easy for his youth to encyst, and he remained forever available. His economic future was solved for him at a single stroke, without anything in particular being demanded of him in exchange. Goethe became accustomed to floating on life—he forgot that he was shipwrecked. Many of the activities which were destiny in him degenerated into hobbies. In the remainder of his life I do not find a moment of painful effort. And effort is only effort when it begins to hurt: anything else is . . . "activity"—the effortless effort which a plant makes to bear flower and fruit. Goethe becomes vegetable. The vegetable is the organic being which does not struggle with its surroundings. Hence it cannot live except in a favorable environment, sustained and coddled by its environment. Weimar was the silken cocoon which the caterpillar secretes out of itself to put between itself and the world.

You will say that I suffer from an unjustified Weimar phobia. Perhaps! But permit me this simple reflection:

You, my dear friend, are an intelligent German. Well—I ask you to imagine to yourself—to "realize," as the English say—the significance of the words "University of Jena" between 1790 and 1825. Did you hear me, my friend? Jena! Jena!! Thousands of miles removed from it in space, and still further removed by my difference from it, I, who am a little Celt-Iberian, born on an arid Mediterranean plateau at an altitude of 2,400 feet above sea level (the average altitude of

{ 171 }

Africa)—I cannot hear that name without trembling. The Jena of that period signifies a fabulous treasure of lofty mental incitements. Is it not a terrible symptom of Weimar's impenetrability that, though it is not a dozen miles from Jena, Jena never managed to affect Weimar in the slightest? I have never been able to imagine Fichte conversing with Frau von Stein, because I do not believe that a buffalo has ever been able to converse with a ghost.

. . . And Goethe had such a magnificent nature! With what exuberance and readiness he responded to any fragment of the real world which flung itself at him! It only took a little wood, and towering flames leaped up! Anything—a trip on the Rhine, a vacation at Marienbad, an interesting woman who crossed Weimar like a wandering cloud . . . flames, flames!

Weimar conveniently separated him from the world; but, as a consequence, it separated him from himself. Goethe looked so hard for his destiny, his destiny was so little apparent to him, because in looking for it he had made up his mind beforehand to flee it. From time to time, turning a corner, he suddenly found himself confronting the I which he was, and then, with exemplary ingenuousness, he exclaimed: *"Eigentlich bin ich zum Schriftsteller geboren!"* "I was really born to be a writer."

Goethe came to feel a mixture of terror and hatred for anything that meant an irrevocable decision. Just as he flees love at the very moment when it is about to

become an abyss into which he will fall—this is, destiny—so he flees the French Revolution, the rising in Germany. Why? Napoleon told him: "Politics is destiny!"

Et cetera, et cetera! The theme is inexhaustible. I have dealt with it here one-sidedly, from but one of its aspects, exaggerating it. But to think, to speak, is always to exaggerate. By speaking, by thinking, we undertake to clarify things, and that forces us to exacerbate them, dislocate them, schematize them. Every concept is in itself an exaggeration.

It would now be proper to show how Goethe, who was unfaithful to his *I*, was precisely the man who taught us all to be true to ours. But let this task remain for the portrait of Goethe which you are to give us. There cannot be a more attractive subject. Because the fact is that neither his botanical ideas about life nor the way he conducted his own life are of value as an introduction, as a hodogetics of man in relation to his I or destiny. Nevertheless, beyond either, what doubt is there that, on our horizon, Goethe signified the great sidereal appearance which gave us the decisive initiation: "Free yourself from *what is superfluous* to yourself!"[10]

What I insist upon is this: in order to clarify the figure of Goethe so that it will signify this more radi-

[10] See my essay, "Goethe, el libertador," published March 22 in the *Neue Züricher Zeitung* and read, with additions, at the University of Madrid on April 30.

cally, so that it will be of use to us, we must reverse our approach to him.

There is but one way left to save a classic: to give up revering him and use him for our own salvation—that is, to lay aside his classicism, to bring him close to us, to make him contemporary, to set his pulse going again with an injection of blood from our own veins, whose ingredients are *our* passions . . . and *our* problems. Instead of becoming centenarians in this centenary, let us try to resurrect our classic by immersing him in life once more.

On June 4, 1866, a favorite student of Mommsen's presented the following thesis for his doctoral disputation at the University of Berlin: *"Historiam puto scribendam esse et cum ira et cum studio."*[11]

There is no naïveté greater than supposing that *ira et studium* are incompatible with "objectivity." As if objectivity were anything but one of the innumerable creations for which we are indebted to the *ira et studium* of man! There was a time when people believed that orchids were born in the air, without roots. There was a time when people believed that culture did not need roots. . . . It was only recently—yet it was long ago. . . .

[11] "I maintain that history should be written with anger and enthusiasm."

Translated from the Spanish by Willard R. Trask

THE SELF AND THE OTHER

❨ My subject is this[1]: Today people constantly talk of law and legality, the state, the nation and internationalism, public opinion and public power, good policy and bad policy, pacifism and belligerencey, country and humanity, social justice and social injustice, collectivism and capitalism, socialization and liberalism, authoritarianism, the individual and the collectivity, and so on and so on. And not only do they talk—in the press, at their clubs, cafés and taverns—they also argue. And not only do they argue—they also fight for the things which these words designate. And once started fighting, they kill each other—by hundreds, by thousands, by millions. It would be ingenuous to suppose that, in what I have just said, I refer specifically to any particular people. It would be ingenuous, because the supposition would be equivalent to believeing that these ferocious labors are confined to special parts of our planet; when, on the contrary, they are a universal phenomenon, which is spreading progressively and from which very few of the European and American peoples will succeed in remaining immune. Doubtless the cruel conflict will take a heavier toll among some peoples than among others and it may be that one group or another will possess the inspired serenity necessary to reduce the havoc to a minimum. Because certainly it is not inevitable; but equally certainly it is very difficult to avoid. Very difficult indeed, because to avoid it will require the collaboration of many factors which differ

[1] This is a shortened version of an essay originally delivered as a lecture in Buenos Aires, 1939.

both qualitatively and in their rank in the hierarchy of values—splendid virtues, together with humble precautions.

One of the precautions—humble, I repeat, but obligatory if a country is to pass unscathed through these terrible times—is to contrive that a sufficient number of persons in it shall be thoroughly aware of the degree to which these ideas (let us call them such), all these ideas about which there is all this talk and fighting and arguing and slaughter, are grotesquely confused and superlatively vague. One of the greatest misfortunes of our time is the acute disparity between the importance which all these questions have at present and the crudeness and confusion of the concepts which they represent.

Few people at this hour—and I refer to the time before the breaking out of this most grim war, which is coming to birth so strangely, as if it did not want to be born—few, I say, these days still enjoy that tranquillity which permits one to choose the truth, to abstract oneself in reflection. Almost all the world is in tumult, is beside itself, and when man is beside himself he loses his most essential attribute: the possibility of meditating, or withdrawing into himself to come to terms with himself and define what it is that he believes and what it is that he does not believe; what he truly esteems and what he truly detests. Being beside himself bemuses him, blinds him, forces him to act mechanically in a frenetic somnambulism.

Nowhere do we better observe that the possibility of

meditation is in truth the essential attribute of man than at the zoo, before the cages of our cousins the monkeys. The bird and the crustacean are forms of life too remote from our own for us to see, comparing them with ourselves, anything but gross, abstract differences, vague by their very extremity. But the ape is so like ourselves that it invites us to pursue the comparison, to discover more concrete and more fertile differences.

If we are able to remain still for a time in passive contemplation of the simian scene, one of its characteristics will presently, and as if spontaneously, become dominant and strike us like a flash of lightning. And this is that the infernal little beasts are constantly on the alert, perpetually uneasy, looking and listening for all the signals that reach them from their surroundings, intent upon their environment as if they feared some constant peril in it, to which they must automatically respond by flight or bite, the mechanical discharge of a muscular reflex. The creature, in short, lives in perpetual fear of the world, and at the same time in a perpetual hunger for the things that are and appear in the world, in an ungovernable hunger which also discharges itself without any possible restraint or inhibition, just as its fear does. In either case it is the objects and events in its surroundings which govern the animal's life, which pull it and push it about like a marionette. It does not rule its own life, it does not live from *itself*, but is always alert to what is going on outside it to what is *other* than itself. Our Spanish word *otro* (other) is nothing but the Latin *alter*. To say, then, that the

animal lives not from *itself* but from what is *other* than itself, pulled and pushed and tyrannized over by that *other*, is equivalent to saying that the animal always lives in estrangement, is beside itself, that its life is essential *alteración*.[2]

As we contemplate this fate of unremitting disquietude, there comes a moment when, using a very Argentinian expression, we say to ourselves, "What a job!" Whereby, with complete ingenuousness and without being aware of it, we set forth the most considerable difference between man and animal. Because the expression means that we feel a strange weariness, a gratuitous weariness, at simply imagining ourselves forced to live among these creatures, perpetually harassed by our environment and tensely attentive to it. But, you will ask, does man perchance not find himself in the same situation as the animal—a prisoner of the world, surrounded by things that terrify him, by things that enchant him, and obliged all his life, inexorably, whether he will or no, to concern himself with them? There is no doubt of it. But with this essential difference—that man can, from time to time, suspend his direct concern with things, detach himself from his surroundings, ignore them, and subjecting his faculty of attention to a radical shift—incomprehensible zoologically—turn, so to

[2] Literally, "otheration." The Spanish word has, in addition to the meaning of English "alteration," that of "state of tumult." Throughout this essay, Ortega plays on the root meanings of this and another equally untranslatable word, *ensimismamiento*, literally, "within-one-self-ness," by extension, "reflection," "contemplation." (*Translator's note.*)

speak, his back on the world and take his stand inside himself, attend to his own inwardness or, what is the same thing, concern himself with himself and not with that which is *other*, with things.

In words which, merely from having been worn down, like old coins, are no longer able to convey their meaning to us with any force, we are accustomed to calling this process: thinking, meditation. But these expressions hide the most surprising thing in the phenomenon: man's power of virtually and provisionally withdrawing himself from the world and taking his stand inside himself—or, to use a magnificent word which exists only in Spanish, that man can *ensimismarse*.

Observe that this marvelous faculty which man possesses of temporarily freeing himself from his slavery to things implies two very different powers: one, his ability to ignore the world for a greater or less time without fatal risk; the other, his having somewhere to take his stand, to be, when he has virtually left the world. Baudelaire expressed this latter difficulty with romantic and mannered dandyism when, asked where he would choose to live, he answered: "Anywhere, so it were out of the world!" But the world is the whole of exteriority, the absolute *without*, which can have no other without beyond itself. The only possible without to this *without* is, precisely, a *within*, an *intus*, the inwardness of man, his *self*, which is principally made up of ideas.

Because ideas possess the most extraordinary condition of being nowhere in the world, of being outside of

all places; although symbolically we situate them in our heads, as Homer's Greeks situated them in the heart or the pre-Homeric Greeks in the diaphragm or the liver. Observe that all these symbolic changes of domicile to which we subject ideas always agree at least in situating them in the viscera; that is, in the innermost part of the body, although the *within* of the body is always a merely relative *within*. In this fashion we give a material expression—since we can give no other—to our suspicion that ideas are in no place in space, which is pure exteriority; but that, in the face of the exterior world, they constitute another world which is not in the world: our inner world.

That is why the animal has always to be attentive to what goes on outside it, to the things around it. Because, even if the dangers and incitements of those things were to diminish, the animal would perforce continue to be governed by them, by the outward, by what is *other* than itself; because it cannot go *within itself*, since it has no *self*, no *chez soi*, where it can withdraw and rest.

The animal is pure *alteración*. It cannot take a stand within itself. Hence when things cease to threaten it or caress it; when they give it a holiday; in short, when the *other* ceases to move it and manage it, the poor animal has virtually to cease to exist, that is: it goes to sleep. Hence the enormous capacity for somnolence which the animal exhibits, the infrahuman torpor which primitive man continues in part; and, on the other hand, the increasing insomnia of civilized man, the almost permanent wakefulness, at times terrible and uncon-

trollable, which afflicts men of an intense inner life. Not many years ago, my great friend Scheler—one of the most fertile minds of our time, a man whose life was an incessant radiating of ideas—died from inability to sleep.

But of course—and with this we touch for the first time upon something which will become apparent to us again and again at almost every turn and winding of this course, if each time on a deeper level and in virtue of more precise and effectual reasons (those which I now give are neither)—of course these two things, man's power of withdrawing himself from the world and his power of taking his stand within himself are not gifts conferred upon man. I must emphasize this for those of you who are concerned with philosophy: they are not gifts conferred upon man. *Nothing that is substantive has been conferred upon man.* He has to do it all for himself.

Hence, if man enjoys this privilege of temporarily freeing himself from things and the power to enter into himself and there rest, it is because by his effort, his toil, and his ideas he has succeeded in retrieving something from things, in transforming them, and creating around himself a margin of security which is always limited but always or almost always increasing. This specifically human creation it technics. Thanks to it, and in proportion to its progress, man can take his stand within himself. But, conversely, man as a technician is able to modify his environment to his own convenience, because, seizing every moment of rest which things allow

him, he uses it to enter into himself and form ideas about this world, about these things and his relation to them, to form a plan of attack against his circumstances, in short, to create an inner world for himself. From this inner world he emerges and returns to the outer, but he returns as protagonist, he returns with a *self* which he did not possess before—he returns with his plan of campaign: not to let himself be dominated by things, but to govern them himself, to impose his will and his design upon them, to realize his ideas in that outer world, to shape the planet after the preferences of his innermost being. Far from losing his own self in this return to the world, he on the contrary carries his self to the *other*, projects it energetically and masterfully upon things, in other words, he forces the *other*—the world—little by little to become himself. Man humanizes the world, injects it, impregnates it with his own ideal substance and is finally entitled to imagine that one day or another, in the far depths of time, this terrible outer world will become so saturated with man that our descendants will be able to travel through it as today we mentally travel through our own inmost selves—he finally imagines that the world, without ceasing to be the world, will one day be changed into something like a materialized soul, and, as in Shakespeare's *Tempest*, the winds will blow at the bidding of Ariel, the spirit of ideas.

I do not say that this is certain—such certainty is the exclusive possession of the *progressivist*, and I am no

progressivist, as you will see. But I do say that it is possible.

And please do not assume, from what you have just heard, that I am an *idealist*. Neither a progressivist nor an idealist! On the contrary, the idea of progress, and idealism—that exquisitely and nobly proportioned name—progress and idealism are two of my *bêtes noires*, because I see in them perhaps the two greatest sins of the last two centuries, the two greatest forms of irresponsibility. But let us leave this subject, to treat it in due season, and for the moment quietly continue along our road.

It seems to me that we can now, if only vaguely and schematically, represent to ourselves humanity's course from this point of view. Let us do so in a brief statement which will at the same time serve us as a résumé and a reminder of all that has preceded.

Man, no less than the animal, finds himself consigned to the world, to the things about him, to his surroundings. At first his existence is hardly different from zoological existence; he too lives governed by his environment, placed among the things of this world as one of them. Yet no sooner do the beings around him give him a moment of repose than man, making a gigantic effort, achieves an instant of concentration, enters into himself, that is, by great labor keeps his attention fixed upon the ideas that spring up within him, ideas which things have evoked and which have reference to the behavior of things, to what the philosopher will later call "the being of things." For the moment it is an

extremely clumsy idea of the world, but one which permits man to outline a first plan of defense, a preconceived course of conduct. But the things around him neither allow him to spend much time in this concentration, nor even if they permitted it would our primigenial man be capable of prolonging this twist of the attention, this fixation upon the impalpable phantoms of ideas, for more than a few seconds or minutes. This inwardly directed attention, this stand within the self, is the most anti-natural and ultra-biological of phenomena. It took man thousands upon thousands of years to educate his capacity of concentration a little—only a little. What is natural to him is to disperse himself, to divert his thought outward, like the monkey in the forest and in his cage in the zoo.

Father Chevesta, explorer and missionary, who was the first ethnographer to specialize in the study of the pygmies—probably, as you know, the oldest known variety of man—and who went to find them in the forests of the Tropics—Father Chevesta, who knows nothing of the theory I am now setting forth and who confines himself to describing what he sees, says in his most recent book, on the dwarfs of the Congo:[3]

They completely lack the power of concentration. They are always absorbed by external impressions, whose continual change prevents them from withdrawing into themselves, which is the indispensable condition for any learning. To put them on a school bench would

[3] *Bambuti, die Zwerge des Congo,* 1932.

be an unbearable torture to these little men. So that the work of the missionary and the teacher becomes extremely difficult.

But even though momentary and crude, this primitive stand within the self tends basically to separate human life from animal life. Because now man, our primigenial man, goes back and again submerges himself in the things of the world, but resisting them, not delivering himself wholly over to them. He has a plan against them, a project for dealing with them, for manipulating their forms, which will produce a minimum transformation of his environment, just enough so that things will oppress him a little less and in consequence allow him more frequent and leisurely withdrawals into himself . . . and so on, time after time.

There are, then, three different moments, which are repeated cyclically throughout the course of human history, in forms each time more complex and rich: 1. Man feels himself lost, shipwrecked upon things; this is *alteración*. 2. Man, by an energetic effort, retires into himself to form ideas about things and his possible dominance over them; this is taking a stand within the self, *ensimismamiento*, the *vita contemplativa* of the Romans, the *theoretikos bios* of the Greeks, *theory*. 3. Man again submerges himself in the world, to act in it according to a preconceived plan; this is action, *vita activa, praxis*.

Accordingly it is impossible to speak of action except in so far as it will be governed by a previous contem-

{ 187 }

plation; and vice versa, the stand within the self is nothing but a projecting of future action.

Man's destiny, then, is primarily *action*. We do not live to think, but on the contrary, we think in order that we may succeed in surviving. This is a point of capital importance, upon which, in my judgment, we must set ourselves in radical opposition to the entire philosophical tradition and make up our minds to deny that *thought*, in any sufficing sense of the word, was given to man once and for all, so that without further ado he finds it at his disposal, as a perfect faculty or power, ready to be employed and exercised, as flight was given to the bird and swimming to the fish.

If this pertinacious doctrine were valid, it would follow that as the fish can—immediately—swim, man could—immediately and without further ado—think. Such a notion deplorably blinds us to the peculiar drama, the unique drama, which constitutes the very condition of man. Because if for a moment, so that we may understand one another here and now, we admit the traditional idea that thought is the characteristic of man—remember *man, a rational animal*—so that to be a man would be, as our inspired forefather, Descartes, claimed, the same as to be *a thinking thing*, we should find ourselves holding that man, by being endowed once and for all with *thought*, by possessing it with the certainty with which a constitutive and inalienable quality is possessed, would be sure of being a man as the fish is in fact sure of being a fish. Now this is a formidable and fatal error. Man is never sure that

he will be able to carry out his thought—that is, in an adequate manner; and only if it is adequate is it thought. Or, in more popular terms: man is never sure that he will be right, that he will hit the mark. Which means nothing less than the tremendous fact that, unlike all other beings in the universe, man can never be sure that he is, in fact, a man, as the tiger is sure of being a tiger and the fish of being a fish.

Far from thought having been bestowed upon man, the truth is—a truth which I cannot now properly argue but can only state—that he has continually been creating thought, making it little by little, by dint of a discipline, a culture or cultivation, a millennial effort over many millennia, without having yet succeeded— far from it—in finishing his work. Not only was thought not given to man from the first, but even at this point in history he has only succeeded in forming a small portion and a crude form of what in the simple and ordinary sense of the word we call thought. And even the small portion gained being an acquired and not a constitutive quality, is always in danger of being lost, and considerable quantities of it have been lost, many times in fact, in the past, and today we are on the point of losing it again. To this extent, unlike all the other beings in the universe, man is never surely *man*; on the contrary, *being man* signifies precisely being always on the point of not being man, being a living problem, an absolute and hazardous adventure, or, as I am wont to say: being, in essence, drama! Because there is drama only when we do not know

what is going to happen, so that every instant is pure peril and shuddering risk. While the tiger cannot cease being a tiger, cannot be detigered, man lives in the perpetual risk of being dehumanized. With him, not only is it problematic and contingent, whether this or that will happen to him, as it is with the other animals, but at times what happens to man is nothing less than *ceasing to be man*. And this is true not only abstractly and generically but it holds for our own individuality. Each one of us is always in peril of not being the unique and untransferable *self* which he is. The majority of men perpetually betray this *self* which is waiting to be; and to tell the whole truth our personal individuality is a personage which is never completely realized, a stimulating Utopia, a secret legend, which each of us guards in the bottom of his heart. It is thoroughly comprehensible that Pindar resumed his heroic ethics in the well-known imperative: "Become what you are."

The condition of man, then, is essential uncertainty. Hence the cogency of the gracefully mannered mot of a fifteenth century Burgundian gentleman: *"Rien ne m'es sure que la chose incertaine."* "I am sure of nought save the uncertain."

No human acquisition is stable. Even what appears to us most completely won and consolidated can disappear in a few generations. This thing we call "civilization"—all these physical and moral comforts, all these conveniences, all these shelters, all these virtues and disciplines which have become habit now, on which we count, and which in effect constitute a repertory or

system of securities which man made for himself like a raft in the initial shipwreck which living always is— all these securities are insecure securities which in the twinkling of an eye, at the least carelessness, escape from man's hands and vanish like phantoms. History tells us of innumerable retrogressions, of decadences and degenerations. But nothing tells us that there is no possibility of much more basic retrogressions than any so far known, including the most basic of them all: the total disappearance of man as man and his silent return to the animal scale, to complete and definitive absorption in the *other*. The fate of culture, the destiny of man, depends upon our maintaining that dramatic consciousness ever alive in our inmost being, and upon our feeling, like a murmuring counterpoint in our entrails, that we are only sure of insecurity.

No small part of the anguish which is today tormenting the soul of the West derives from the fact that during the past century—and perhaps for the first time in history—man reached the point of believing himself secure. Because the truth is that the one and only thing he succeeded in doing was to feel and create the pharmaceutical Monsieur Homais, the net result of progressivism! The progressivist idea consists in affirming not only that humanity—an abstract, irresponsible, nonexistent entity invented for the occasion—that humanity progresses, which is certain, but furthermore that it progresses necessarily. This idea anaesthetized the European and the American to that basic feeling of risk which is the substance of man. Because if humanity

inevitably progresses, that is almost saying that we can abandon all watchfulness, stop worrying, throw off all responsibility, or, as we say in Spain, "snore away" and let humanity bear us inevitably to perfection and pleasure. Human history thus loses all the sinew of drama and is reduced to a peaceful tourist trip, organized by some transcendent "Cook's." Traveling thus securely toward its fulfillment, the civilization in which we are embarked would be like that Phaeacian ship in Homer which sailed straight to port without a pilot. This security is what we are now paying for. That, gentlemen, is one of the reasons why I told you that I am not a progressivist. That is why I prefer to renew in myself, at frequent intervals, the emotion aroused in my youth by Hegel's words at the beginning of his *Philosophy of History:* "*When we contemplate the past, that is, history,*" he says, "*the first thing we see is nothing but— ruins.*"

Let us, in passing, seize the opportunity to see, from the elevation of this vision, the element of frivolousness, and even of marked vulgarity, in Nietzsche's famous imperative: "*Live dangerously.*" (Which, furthermore, is not Nietzsche's but the exaggeration of an old Italian Renaissance motto, which Nietzsche, I believe, must have known through Burckhardt. The Italians of today, especially the super-Italians of today, nevertheless go about shouting Nietzsche's motto. Because it is characteristic of the contemporary supernationalist to be ignorant of his nation, of the rich past of his nation. Otherwise, instead of taking Nietzsche's

version, the Italians could have learned, directly from Ariosto, a motto which is different and the same: *Vivere risolutamente.*) Because he does not say "Live alertly," which would have been good; but, "Live dangerously." And this shows that Nietzsche, despite his genius, did not know that the very substance of our life is danger and that hence it is rather affected—not to say trying too hard for an effect—to propose to us as something new, added and original that we should seek and collect danger. An idea, furthermore, which is typical of the period which called itself "*fin de siècle,*" and which will be known in history—it culminated about 1900— as the period in which man felt himself most secure and, at the same time, as the epoch—with its stiff shirts and frock-coats, its *femmes fatales*, its affectation of perverseness, and its Barresian cult of the "I"—of shoddy vulgarity par excellence. In every period there are ideas which I would call "fishing" ideas, ideas which are expressed and proclaimed precisely because it is known that they will not come to pass; which are thought of only as a game, as foolishness—some years ago, for example, there was a rage in England for wolf stories, because England is a country where the last wolf was killed in 1663 and hence has no authentic experience of wolves. In a period which has no strong experience of insecurity, like the *fin de siècle* period, they play at the dangerous life.

Enough of all this—thought is not a gift to man but a laborious, precarious and volatile acquisition.

With this idea in mind, you will understand that I

see an element of absurdity in the definition of man put forth by Linnaeus and the eighteenth century: *homo sapiens*. Because if we take this expression in good faith, it can mean only that man, in effect, knows —in other words, that he knows all that he needs to know. Now nothing is further from the reality. Man has never known what he needed to know. But if we understand *homo sapiens* in the sense that man knows some things, a very few things, but does not know the remainder, it would seem to me more appropriate to define him as *homo insciens, insipiens*, as man the unknowing. And certainly, if we were not now in such a hurry, we could see the good judgment with which Plato defines man precisely by his ignorance. Ignorance is, in fact, man's privilege. Neither God nor beast is ignorant—the former because he possesses all knowledge, the latter because he needs none.

It is clear, then, that man does not exercise his thought because he finds it amusing, but because, obliged as he is to live submerged in the world and to force his way among things, he finds himself under the necessity of organizing his psychic activities, which are not very different from those of the anthropoid, *in the form* of thought—which is what the animal does not do.

Man, then, rather than by what he *is*, than by what he *has*, escapes from the zoological scale by what he *does*, by his conduct. Hence it is that he must always be watchful of himself.

This is something of what I should like to suggest in the phrase (which appears to be but a phrase) that *we*

do not live in order to think but that *we think in order to succeed in subsisting or surviving.* And you see how this attributing thought to man as an innate quality—which at first seems to be a homage and even a compliment to our species—is, strictly speaking, an injustice. Because there is no such gift, no such gratuity; thought, on the contrary, is a laborious fabrication and a conquest which, like every conquest, be it of a city or of a woman, is always unstable and fugitive.

This consideration of thought was necessary as an aid to understanding my earlier statement that man is primarily and fundamentally action. In passing, let us do homage to the first man who arrived at this truth with such clarity; it was not Kant nor Fichte, it was that inspired madman Auguste Comte.

We saw that *action* is not a random fisticuffs with the things around us or with our fellow men: that is the infrahuman, that is subjection to the *other. Action* is to act upon the material environment or upon other men in accordance with a plan conceived in a previous period of contemplation or thought. There is then, no authentic action if there is no thought, and there is no authentic thought if it is not duly referred to action and made virile by its relation to action.

But this relation—which is the true one—between action and contemplation has been persistently misunderstood. When the Greeks discovered that man thought, that there existed in the universe that strange reality known as thought (until then man had not thought, or, like the *bourgeois gentilhomme*, had done

so without knowing it), they felt such an enthusiasm for ideas that they conferred upon intelligence, upon the *logos*, the supreme rank in the universe. Compared with it, everything else seemed to them ancillary and contemptible. And as we tend to project into God whatever appears to us to be the best, the Greeks, with Aristotle, reached the point of maintaining that God had no other occupation but to think. And not even to think about things—that seemed to them, as it were, a debasement of the intellectual process. No, according to Aristotle, God does nothing but think about thought —which is to convert God into an intellectual, or, more precisely, into a modest professor of philosophy.—But I repeat that, for them, this was the most sublime thing in the world and the most sublime thing which a being could do. Hence they believed that man's destiny was solely to exercise his intellect, that man had come into the world to meditate, or, in our terminology, to take a stand within himself (*ensimismarse*).

This doctrine has been given the name "intellectualism"; it is an idolatry of the intelligence which isolates thought from its setting, from its function in the general economy of human life. As if man thinks because he thinks, and not because, whether he will or not, he has to think in order to maintain himself among things! As if thought could awaken and function of its own motion, as if it began and ended in itself, and were not —as is the true state of the case—engendered by action and having its roots and its end in action! We owe innumerable things of the highest value to the Greeks,

but they have put chains on us too. The man of the West still lives, to no small degree, enslaved by the preferences of the men of Greece—preferences which, operating in the subsoil of our culture, have for eight centuries turned us from our proper and authentic Occidental vocation. The heaviest of these chains is "intellectualism"; and now, when it is imperative that we change our course and take a new road—in short, get on the right track—it is of the greatest importance that we resolutely rid ourselves of this archaic attitude, which has been carried to its extreme during these last two centuries.

Under the name first of Reason, then of Enlightenment, and finally of Culture, the most radical equivocation of terms and the most indiscreet deification of the intelligence were effected. Among the majority of the thinkers of the period, especially among the Germans— for example, among those who were my masters at the beginning of the century—culture, thought, came to fill the vacant office of a God who had been put to flight. All my work, from its first stutterings, has been a fight against this attitude which many years ago, I called the "bigotry of culture." The BIGOTRY OF CULTURE because it presented us with culture, with thought, as something justified by itself, that is, which requires no justification but is valid by its own essence, whatever its concrete employment and its content may be. Human life was to put itself at the service of culture because only thus would it become charged with value. From which

it would follow that human life, our pure existence, was, in itself, a mean and worthless thing.

This way of reversing the relation between life and culture, between action and contemplation, brought it about that, during the last century—for a comparatively short period, then—there has been an overproduction of ideas, of books and works of art, a real cultural inflation. We have arrived at what—jokingly, because I distrust "-isms"—we might call a "capitalism of culture," a modern reflection of Byzantinism. There has been production for production's sake, instead of production in view of consumption, in view of the necessary ideas which the man of today needs and can absorb. And, as occurs in capitalism, the market became saturated and crisis ensued. Let no one tell me—at least in this place—that the greater part of the immense changes which have recently occurred have taken us by surprise. For twenty years I have been announcing them and denouncing them. To mention no other subject than the one we are now treating, reference may be made to my essay, formally and programmatically entitled "The Reform of Intelligence."

But the most momentous thing about the intellectual aberration which this "bigotry of culture" signifies does not lie here; it lies in presenting culture, contemplation, thought, as a grace or jewel which man is to add to his life—hence as something which lies outside of his life and as if there were life without culture and thought, as if it were possible to live without contemplation. Men were set, as it were, before a jeweler's

window—were given the choice of acquiring culture or doing without it. And it is clear that, faced with such a dilemma, during the years we are now living men have not hesitated, but have resolved to explore the second alternative to its limits and seek to flee from all taking a stand within the self and to give themselves up to the opposite extreme. That is why Europe is in extremities today.

The intellectualist aberration which isolates contemplation from action was followed by the opposite aberration—the voluntarist aberration, which rejects contemplation and deifies pure action. This is the other way of wrongly interpreting the foregoing thesis, that man is primarily and fundamentally *action*. Undoubtedly every idea, even the truest, is susceptible of misinterpretation; undoubtedly every idea is dangerous; this we are obliged to admit once and for all, but upon condition that we add that this danger, this latent risk, is not limited to ideas but is connected with everything, with absolutely everything, that man does. Hence I have said that the substance of man is purely and simply danger. Man always travels along precipices, and, whether he will or no, his truest obligation is to keep his balance.

As has happened on other occasions in the known past, now once again—and I am not referring to the present weeks, but to the present years, and almost to our century—once again our peoples are submerging themselves in the *other*. The same thing that happened in Rome! Europe began by letting itself be confused by

pleasure, as Rome was by what Ferrero has called "luxury"—an excess, an extravagance, of commodities. Confusion through pain and terror followed immediately. As in Rome, social conflicts and the consequent wars stupefied men's souls. And stupefaction, the extreme form of *alteración*—stupefaction, when it persists, becomes stupidity. It has aroused some comment that, for a long time and with the insistence of a leitmotiv, I have referred in my writings to the insufficiently recognized fact that, even in Cicero's time, the ancient world was becoming stupid. It has been said that his master Posidonius was the last man of that civilization who was able to set himself before things and think about them effectually. The capacity to take a stand within the self, to withdraw serenely into our incorruptible consciousness, was lost—as it threatens to be lost in Europe if something is not done to prevent it. Nothing is talked about but action. The demagogues, impresarios of *alteración*, who have already caused the death of several civilizations, harass men so that they will not reflect; manage to keep them herded together in crowds so that they cannot reconstruct their individuality in the one place where it can be reconstructed, which is in solitude. They cry down service to truth, and in its stead offer us: *myths*. On a later day we shall see exactly why. And by all these means they succeed in throwing men into a passion, in putting them, between ardors and terrors, *beside themselves*. And clearly, since man is the animal which has succeeded in putting himself *inside himself*, when man is *beside*

himself his aspiration is to descend and he falls back into animality. Such is the spectacle, always the same, of every epoch in which pure action is deified. The stage is filled with crimes. Human life loses value, is no longer regarded, and all forms of violence and spoliation are practiced. Hence whenever the figure of the pure man of action rises above the horizon and becomes dominant, the first thing for us to do is to hold tight. Anyone who would really like to learn what effects spoliation produces in a great empire can see them set forth in the first great book to be written on the Roman Empire—until now we did not know what that empire was. I refer to the book by the great Russian savant Rostovtzeff, entitled *Social and Economic History of the Roman Empire.*

Removed in this manner from its normal connection with contemplation, with taking a stand within the self, *pure action* permits and produces only a concatenation of stupidities which we might better call a *disconcatenation*. So we see today that an absurd attitude justifies the appearance of an opposing attitude equally unreasonable; reasonable enough, however; and so on indefinitely. Such is the extreme to which political matters in the West have come!

Such being the case, it would seem sensible that, wherever circumstances give us even the slightest respite, we attempt to break this magic circle of *alteración*, which flings us from one folly to another; it would seem sensible that we should say to ourselves—as, after all, we say to ourselves many a time in our more ordinary

life when our surroundings press upon us, when we feel lost in a whirlpool of problems: Quietly now! What meaning has this command? Simply that of inviting us to suspend for a moment the action which threatens to distract us and make us lose our heads; to suspend action for a moment so that we may withdraw into ourselves, review our ideas of the circumstances, and work out a plan of strategy.

Without a strategic retreat into the self, without vigilant thought, human life is impossible. Call to mind all that mankind owes to certain great withdrawals into the self! It is no chance that all the great founders of religions preceded their apostolates by famous retreats. Buddha withdrew to the forest; Mohammed withdrew to his tent, and even there he withdrew from his tent by wrapping his head in his cloak; above all, Jesus went apart into the desert for forty days. What do we not owe to Newton! Well, when someone, amazed that he had succeeded in reducing the innumerable phenomena of the physical world to such a precise and simple system, asked him how he had succeeded in doing so, he replied ingenuously: *"Nocte dieque incubando,"* "turning them over day and night"—words behind which we glimpse vast and profound withdrawals into the self.

In the world today, gentlemen, a great thing is dying—it is truth. Without a certain margin of tranquillity, truth succumbs.

Hence, faced with the incitements to *alteración* which today reach us from every point of the compass and

from every department of life, I believed that I should begin this course of lectures, should put before them by way of prologue, a sketch of this doctrine of withdrawal into the self, even though it be a hurried sketch, even though I have been unable to dwell on such parts of it as I would have wished to, and have had to pass over others in silence—for example, I have not been able to point out that withdrawal into the self, like everything human, has sex, that there is a masculine form of it, and another which is feminine. Which cannot be otherwise, in view of the fact that woman is not *him*self but *her*self.

Similarly, the man of the East withdraws into the self in a different way from the man of the West. The Occidental does it in clarity of mind. Remember Goethe's lines:

> *I, I confess, am of the race of those*
> *Who from the dark aspire to clarity.*

Europe and America mean the attempt to live by clear ideas, not by myths. Because clear ideas have ceased to exist, the European now feels lost and demoralized.

Machiavelli—not to be confused with "Machiavellianism"—tells us neatly that when an army is demoralized and scatters, losing its formations, there is only one salvation: *"Ritornare al segno," "to return to the banner,"* gather beneath its folds, and regroup the scattered hosts beneath that sign. Europe and America must also *ritornare al segno* of clear ideas. The new generations, who delight in clean bodies and pure acts,

must integrate themselves in the clear idea, in the strictly constructed idea, which is not redundant, which is not flabby, which is necessary to life. Let us return— I repeat—from myths to clear and distinct ideas, as, three centuries ago, they were called, with programmatic solemnity, by the keenest mind which the West has known: René Descartes, "that French cavalier who set out at such a good pace," as Péguy put it. I know very well that Descartes and his rationalism are outdated, but man is nothing positive if he is not continuity. To excel the past we must not allow ourselves to lose contact with it; on the contrary, we must feel it under our feet because we have raised ourselves upon it.

Translated from the Spanish by Willard R. Trask